Egon Eiermann
Deutsche Olivetti
Frankfurt am Main

HIRMER

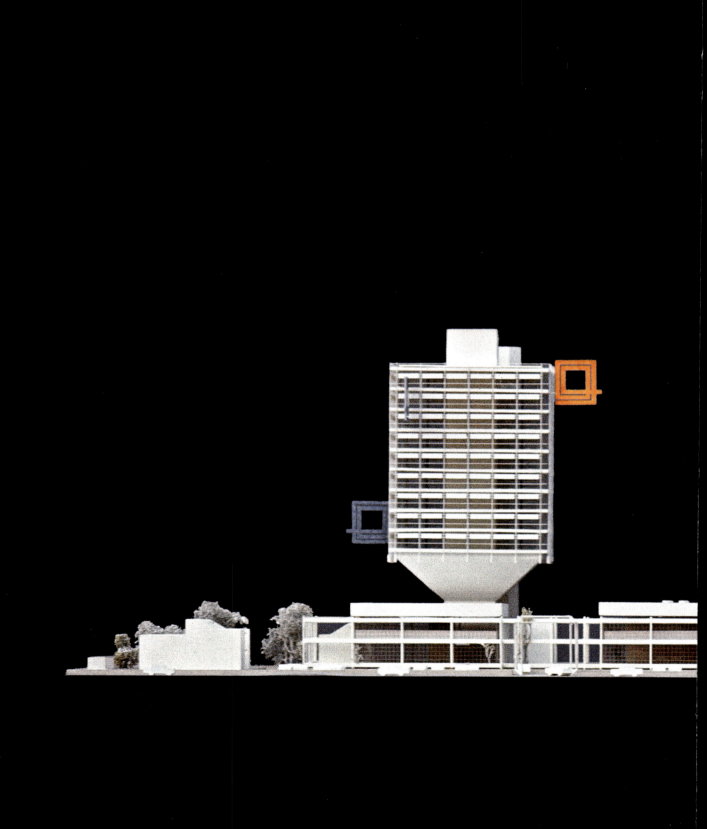

**Egon Eiermann
Deutsche Olivetti
Frankfurt am Main**

**Fotografie/Photography
Klaus Kinold**

**Text
Wolfgang Pehnt**

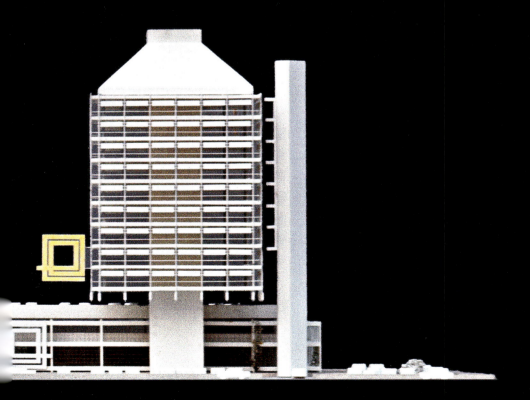

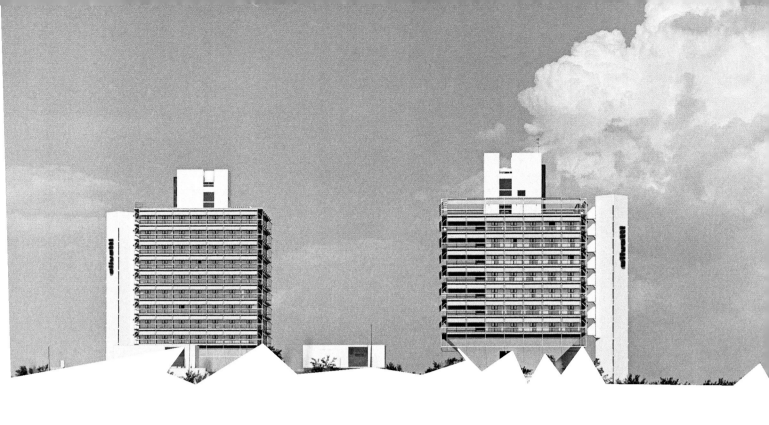

Blick von der Autobahn auf die beiden Olivetti-Türme in Frankfurt-Niederrad, zum Zeitpunkt der Aufnahme noch kaum verbaut. Links der neungeschossige Büroturm, rechts der siebengeschossige Hotelturm.

View from the motorway of the two Olivetti towers in Frankfurt-Niederrad, which was then hardly developed. On the left, the nine-story office tower; on the right, the seven-story hotel tower.

Egon Eiermann
Deutsche Olivetti
Frankfurt am Main

Zu seinen Hochhäusern hatte Frankfurt ein wechselndes Verhältnis. In den frühen Nachkriegsjahren galten Bürotürme als notwendiges Übel. Man hielt sich an ‚maßvolle' Lösungen. Als sie mit den Jahren und Jahrzehnten trotzdem höher emporwuchsen und sogar von der Wetterau oder vom Taunus aus wahrzunehmen waren, entwickelte sich so etwas wie Stolz auf die neuen Riesen. Diese – wenigstens für Mitteleuropäer – imponierend hohen Bauten entstanden im Bankenviertel, im Westend der City und im Messegelände. Die beiden Türme, die Olivetti in Frankfurt-Niederrad errichtete und deren Höhe nur knapp über 50 Meter beträgt, stehen dagegen auf der südlichen Mainseite – ‚maßvoll' auf jeden Fall.

Wer ihre Finesse bewundern will, muss sich in eines jener Arbeitsgettos begeben, in denen Großstädte der Bundesrepublik ihre Dienstleistungsbetriebe auszulagern suchten. So etablierte Hamburg die City Nord, die Verwaltungsbauten aufnahm, für die im Zentrum kein Platz mehr war. In Westberlin hatte sich schon in Vorkriegszeiten ein neuer Stadtkern in Charlottenburg herausgebildet. Frankfurt wies auf dem südlichen Mainufer die Bürostadt Niederrad aus, bevor die Stadt weitere Wohngebiete im bürgerlichen Westen und im großbürgerlichen Finanzsektor opferte.

Viele dieser Planungen wurden zu städtebaulichen Misserfolgen und blieben unbelebte Büroquartiere. Frankfurt-Niederrad teilt mit den meisten dieser Aussiedlungen die Nachteile des Genres, auch wenn inzwischen Wohnbebauungen in Baulücken eingeschoben wurden. Immerhin bot der Ort die Nähe zu Autobahn, Hauptbahnhof und Flughafen. An zwei Seiten fasst der Stadtwald das Quartier ein, an einer der Fluss. Die einzelnen Konzernbauten boten allerdings nur selten Schmuckstücke, abgesehen vom benachbarten Nestlé-Haus von Max Meid und Helmut Romeick. Und vor allem der Baugruppe, die der Olivetti-Konzern von 1967 bis 1972 errichtete.

Stile Olivetti
Design war der Firma bereits ein Anliegen, als es anderswo noch ein Fremdwort war. Olivetti hatte zusammen mit Künstlern und Designern

Egon Eiermann
Deutsche Olivetti
Frankfurt am Main

Frankfurt has had a love-hate relationship with its high-rises. In the first postwar years they were regarded as a necessary evil. One adhered to restrained solutions. As over the years and decades they nevertheless grew taller and taller and were visible from the Wetterau or Taunus, the new giants began to be regarded with pride. These strikingly tall—at least by Central European standards—buildings were erected in the banking district, the downtown Westend quarter, and in the fairground area. The two high-rises that Olivetti built in Frankfurt-Niederrad, whose height is only slightly over 50 meters, are located on the south side of the Main river—and are certainly restrained.

Those who want to admire their finesse must travel to one of those work ghettos to which large cities in West Germany have relocated their service sector buildings. Thus Hamburg created City Nord to accommodate administration buildings for which there was no more room in the city center. A new urban hub in the Charlottenburg quarter in western Berlin was already established before the war. Frankfurt created the office district of Niederrad on the south bank of the Main river, before sacrificing other residential neighborhoods in the middle-class Westend and in the upper-class financial sector.

Many of these projects ended up as urban failures and remained unpopular office districts. Frankfurt-Niederrad shares with the majority of these relocated quarters the disadvantages of the genre, even though residential housing has in the meantime filled the gaps between buildings. The location at least offers proximity to the motorway, the central train station, and the airport. A forest surrounds the district on two sides, the river on another. The corporate buildings, however, are seldom exceptional, with the exception of the Nestlé House by Max Meid and Helmut Romeick. And above all the complex of buildings next door, erected by the Olivetti Corporation between 1967 and 1972.

Stile Olivetti
Design was a major concern for the company when the concept was still unfamiliar to others. Olivetti enlisted artists and designers to aid in

in seinem piemontesischen Heimatort Ivrea Meilensteine gesetzt. Unter seinen Büromaschinen, den mechanischen, elektrischen und elektronischen Schreibmaschinen, Computern, Druckern, Telefonen, Rechnern, Tablets und Notebooks, gelten viele als Ikonen. Schreibmaschinen wie die Lexikon 80, die Lettera 22 oder die Kofferschreibmaschine Valentine boten Beispiele für Italianità im Industriedesign, farbenfroh, dem italienischen Lifestyle nahe wie die Vespa oder der Fiat Topolino. Manche wurden in große Kulturinstitutionen der Welt wie das New Yorker Museum of Modern Art oder die dritte Kasseler Documenta-Schau aufgenommen. Das Kunstgewerbemuseum Zürich half 1961 mit einer großen Ausstellung den Begriff ‚Stile Olivetti' zu festigen, dessen sich auch das Unternehmen bediente.

Zu den europäischen Förderstätten des Design hielt man bei Olivetti stets Kontakt. Der Bauhaus-Schüler Xanti Schawinsky arbeitete in den 1930er Jahren als Grafiker für die Firma. Als nach dem Zweiten Weltkrieg die Hochschule für Gestaltung in Ulm die Bauhaus-Stafette weitertrug, interessierten sich Olivetti-Leute auch für das, was die HfG-Leute auf dem Ulmer Kuhberg trieben. Zur Unternehmenskultur der Piemonteser gehörten jedoch mehr als die ‚Gute Form', der rationale Entwurf und die wirtschaftliche Leistung. Schon in den Anfängen pflegte man in Ivrea soziales Engagement, kümmerte sich um kulturelle Betreuung, um Kindergärten, Mütterfürsorge und Begabtenförderung. Adriano Olivetti, Sohn des Unternehmensgründers Camillo, ging in seinem

setting milestones in its headquarters in Ivrea in the Piedmont region of Italy. Many of its office machines, including mechanical, electric, and electronic typewriters, computers, printers, telephones, calculators, tablets, and notebooks, now enjoy the status of icons. Typewriters such as the Lexikon 80, the Lettera 22, or the portable Valentine embodied italianità in industrial design, as colorful and representative of Italian lifestyle as the Vespa or the Fiat Topolino. Some of them were exhibited in major cultural institutions such as the New York Museum of Modern Art or at the third edition of the documenta art fair in Kassel. The Kunstgewerbemuseum Zurich helped to firmly establish the term Stile Olivetti with a major exhibition in 1961, a concept the firm also made use of.

Olivetti regularly cultivated relations with European centers of design. The Bauhaus student Xanti Schawinsky worked as a graphic artist for the company in the 1930s. When after World War II the Hochschule für Gestaltung (School of Design) in Ulm took up the baton from the Bauhaus, Olivetti followed with interest what they were doing on the Kuhberg near Ulm. The Piedmont firm's corporate culture encompassed more than simply good form, rational design, and economic performance. From the very beginning Ivrea had practiced social commitment, sponsored cultural activities, nurseries, maternity care, and scholarships for outstanding students. Adriano Olivetti, son of

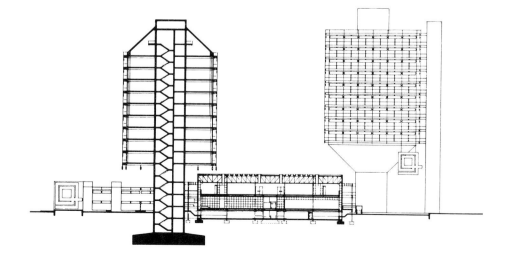

Schnitt-Ansicht der Entwurfsvariante mit Hängehaus

Sectional view of the design variant with one tower as a hanging construction

Engagement weit über das ursprüngliche Firmenprogramm hinaus. Der von ihm ins Leben gerufene ‚Movimento Comunità' war eine Bewegung, die auf die Kulturpolitik Italiens Einfluss nehmen sollte und sich als sozial, liberal, demokratisch und föderal verstand. Eine stabile politische Massenbewegung wurde allerdings nicht daraus. Adriano Olivetti saß zeitweise als alleiniger Abgeordneter seiner Partei im römischen Parlament.

Es versteht sich, dass Olivetti auch für seine Werkstätten, Niederlassungen und Showrooms Wert auf qualitätsvolle Architektur legte. In der kleinen Stadt Ivrea, am Eingang des Aosta-Tals gelegen, entstand eine ganze Firmenstadt, die 2018 mit dem Unesco-Prädikat eines Weltkulturerbes ausgezeichnet wurde.[1] Die seinerzeit jungen Architekten Luigi Figini und Gino Pollini errichteten ab den 1930er Jahren Produktionsgebäude mit zweischaligen Glasfassaden, mit Sozialbauten und Wohnanlagen. Adriano Olivetti verpflichtete auch für die Niederlassungen im Ausland national respektierte und international prominente Architekten. Kenzo Tange in Japan, Louis Kahn und Richard Meier in den USA, James Stirling in Großbritannien gehörten zu seiner Architekten-Comunità. Carlo Scarpa durfte den Showroom am Markusplatz in Venedig gestalten. „In Zeiten wie den unseren, in denen die Moderichtungen sich abwechseln und alles im Zeichen schneller Veränderungen steht, muss sich die Architektur an bleibenden kulturellen Werten orientieren."[2]

Eine Art Testament
Daher war es für Egon Eiermann (1904–1970) ein ehrenvoller Auftrag, als Olivetti ihm den Bau der Deutschen Olivetti in Frankfurt am Main übertrug. Kurz nach dem IBM-Campus in Stuttgart-Vaihingen sollte dieses Projekt für einen weiteren Worldplayer auf dem Büromaschinen-Markt zu einer Krönung seines Werks werden. Die Vollendung erlebte Eiermann nicht mehr; er starb zwei Jahre vorher an einer Herzattacke. Das Bauwerk musste unter der Regie seiner Mitarbeiter vollendet werden.

Mit Eiermann verabschiedete sich ein Architekt, der im Deutschland der Nachkriegsjahre – neben dem Antipoden Hans Scharoun, den man bei Olivetti auch in Betracht gezogen zu haben scheint – zu den bedeutenden Baumeistern gehörte. „Die Entscheidung, Professor Egon Eiermann … zu beauftragen, wurde getroffen … weil seine Architektur durch alle diese Jahre –

the firm's founder, Camillo, went far beyond the usual corporate program in his social commitment. He initiated the Movimento Comunità, a movement that regarded itself as social, liberal, democratic, and federal, and aimed to exert influence on Italy's cultural policies. It did not grow, however, into a stable political mass movement. For a while Adriano Olivetti sat as the lone member of his party in the parliament in Rome.

It is obvious that Olivetti also valued high-quality architecture for its workshops, offices, and showrooms. In the small town of Ivrea, at the entrance to the Aosta Valley, an entire company town was erected that was conferred UNESCO World Heritage status in 2018.[1] From the 1930s on the young architects Luigi Figini and Gino Pollini erected here production buildings with double-leaf glass facades, accompanied by structures with social and residential functions. Adriano Olivetti likewise hired nationally respected and internationally prominent architects for branch offices abroad. Kenzo Tange in Japan, Louis Kahn and Richard Meier in the USA, James Stirling in Great Britain: all belonged to his comunità of architects. Carlo Scarpa was entrusted with the showroom on St. Mark's Square in Venice. "In times such as these, when fashions change quickly and everything seems to be in constant flux, then architecture has to follow permanent cultural values."[2]

A Kind of Testament
For these reasons it was enticing for Egon Eiermann (1904–1970) when Olivetti commissioned the building of Deutsche Olivetti in Frankfurt am Main. Coming shortly after the IBM campus in Stuttgart-Vaihingen, this project for another world player on the office machine market was meant to crown his oeuvre. Eiermann did not live to see its completion, dying two years earlier from a heart attack. The building was finished under the direction of members of his studio.

Eiermann's death represented the departure of a figure who—along with his antipode Hans Scharoun, apparently also considered for the job by Olivetti—belonged to the outstanding architects of postwar Germany. "The decision to commission Professor Egon Eiermann … was made because all of these years his architecture—without repetition and in constant searching and experimenting—has continued the tradition of the most lively and most ex-

ohne Wiederholungen und unter ständigem Suchen und Experimentieren – die Tradition der lebendigsten und außergewöhnlichsten architektonischen Bewegung Deutschlands fortgesetzt hat."[3] Eiermann hatte nach Wohnungs-, Verwaltungs- und Industriebauten auch sakrale Gebäude wie die Matthäuskirche in Pforzheim und die Kaiser-Wilhelm-Gedächtniskirche in Berlin entworfen. Mit den Pavillons der Weltausstellung in Brüssel (gemeinsam mit Sep Ruf), der Deutschen Botschaft in Washington, dem Abgeordnetenhochhaus in Bonn und seiner umfangreichen Berater- und Jurorentätigkeit war er im letzten Dutzend seiner Lebens- und Arbeitsjahre zu einer Autorität in der vom Staat verantworteten Baukultur der Bundesrepublik geworden.

traordinary architectural development in Germany."[3] After having designed residential, administration, and industrial buildings, Eiermann created religious buildings such as the St. Matthew Church in Pforzheim and the Kaiser William Memorial Church in Berlin. Thanks to his pavilion for the world's fair in Brussels (in collaboration with Sep Ruf), to the German Embassy in Washington, and the Parliament in Bonn—as well as to his extensive activities as a consultant and juror—during the last dozen years of his professional career he rose to become an authority in the state-supported architectural culture of the Federal Republic.

1 Caroline Stapenhorst, Luciano Motta: Rundgang durch die Città Olivettiana. In: Bauwelt, 2018, Heft/*issue* 22, S./*pp.* 20 ff.
2 Renzo Zorzi, Direktor für kulturelle Beziehungen/*Director Cultural Affairs* bei/*at* Olivetti. In: Olivetti Presse Informationen, Frankfurt, 5.10.1972.
3 Deutsche Olivetti in Frankfurt, Ivrea 1972.

Literatur in Auswahl/Selected bibliography

Eberhard Schulz: Das Haus als Kelch. In: Frankfurter Allgemeine Zeitung, 19.4.1968

Egon Eiermann unter Mitarbeit von Heinz Jakubeit, Rudolf Wiest, Peter Poike: Über architektonische Form. In: Fridericiana, Zeitschrift der Universität Karlsruhe. Heft 3, 1968. S. 31 ff.

Eberhard Schulz: Die Herrschaft der Türme. Über den Versuch, kleiner zu sein als man ist. In: Frankfurter Allgemeine Zeitung, 21.10.1972

Peter M. Bode: Qualität aus Liebe zum Detail. Die letzten Bauten von Egon Eiermann. In: Süddeutsche Zeitung, 4./5.11.1972

Egon Eiermann und das Verwaltungs- und Ausbildungszentrum der Deutschen Olivetti in Frankfurt am Main. In: Bauwelt, Jg. 64, 13, 9.4.1973

Beratungsstelle für Stahlverwendung (Hg.): Verwaltungs- und Ausbildungszentrum der Deutschen Olivetti in Frankfurt am Main. München 1974

Wulf Schirmer (Hg.): Egon Eiermann 1904-1970. Bauten und Projekte. Stuttgart 1984, ⁴2002

Egon Eiermann: Rückblicke. In: Bauwelt, Jg. 85, 38, 7.10.1994

Eva Bothe: Architektur für Olivetti. Diss. 1992. Hamburg 1997

Ulf Jonak: Die Frankfurter Skyline. Frankfurt 1997

Marianne Rodenstein (Hg.): Hochhäuser in Deutschland. Stuttgart 2000

Annemarie Jaeggi (Hg.): Egon Eiermann (1904-1970). Die Kontinuität der Moderne. The Continuity of Modernism. Ostfildern 2004

Egon Eiermann, Südwestdeutsches Archiv für Architektur und Ingenieurbau (Hg.): Briefe des Architekten 1946-1970. Karlsruhe ³2009

Sara Stroux: Architektur als Instrument der Unternehmenspolitik. Konzernhochhäuser westdeutscher Industrieunternehmen in der Nachkriegszeit. Diss. ETH Zürich 2009

Adrian Seib: Olivetti-Türme, Egon Eiermann. In: Wilhelm E. Opatz (Hg.). Frankfurt 1970-1979. Hamburg 2018

Olivetti. Industrie-Kultur. Bauwelt, Jg. 109, 22, 2.11.2018

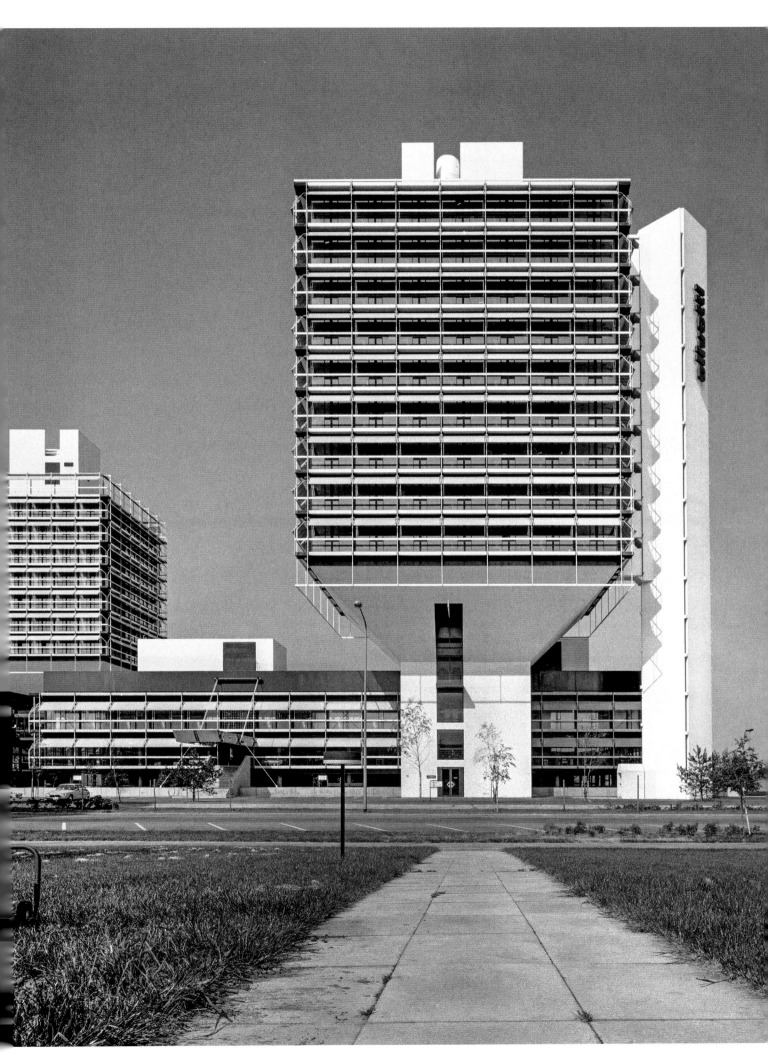

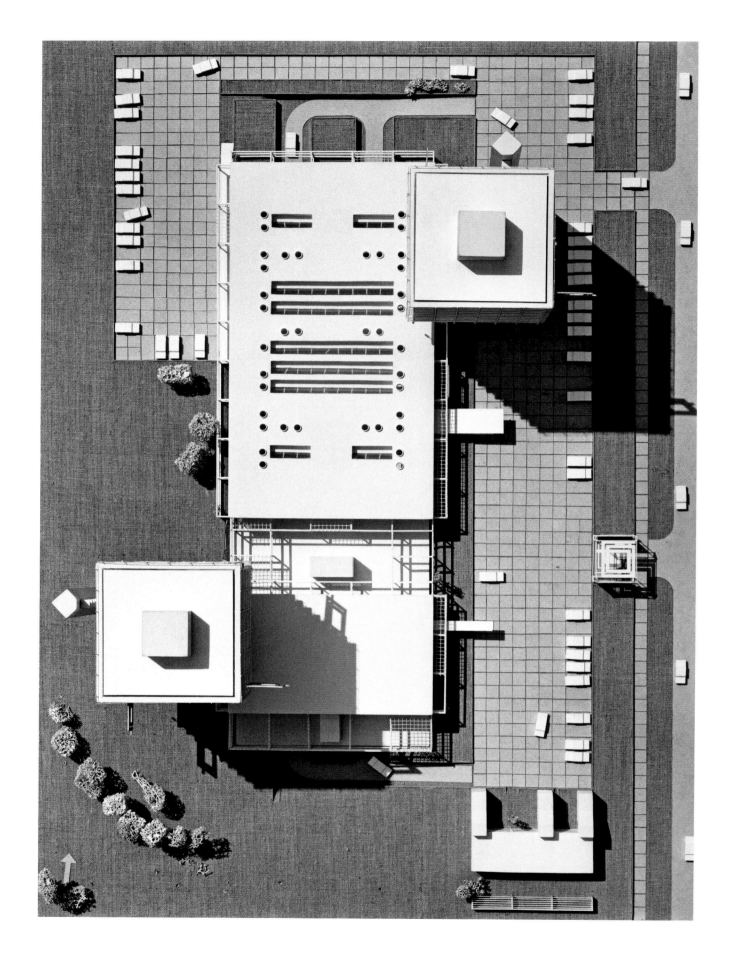

Ohne Rücksicht auf Zeitaufwand und Planungskosten war Eiermann unermüdlich im Angebot von Alternativen. Die Modellaufnahmen zeigen den ausgeführten Entwurf mit zwei Kelchhäusern.

Ignoring the costs and efforts in time and planning, Eiermann tirelessly offered different options. The photographs of the model depicts the executed design with two goblet-shaped towers.

Entsprechend der Firmenphilosophie Olivettis waren neben Verwaltung, Verkauf und technischem Kundendienst auch Orte der Gastfreundlichkeit, der Information und der Weiterbildung verlangt: Foyer, Ausstellungshalle, Hörsäle, Konferenzzimmer und Schulungsräume, eine Cafeteria, ein Hotel, das mit dem wohnlicheren Namen ‚Albergo' belegt wurde. Mit den unterschiedlichen Nutzungen, den etwa 350 Beschäftigten, den 120 bis 150 Kursteilnehmern und Hotelgästen sowie dem Publikumsverkehr, ließ sich in dem damals eher abseitigen, wenn auch durch S-Bahn und andere Verkehrsmittel erschlossenen Bürostandort Niederrad und auf dem langen schmalen Grundstück fast so etwas wie belebte Stadt suggerieren.

Unter einem geteilten, zweigeschossigen Riegel liegen im ausgeführten Projekt offene Pkw-Einstellplätze. Der kleinere Teil des zweigeteilten Flachbaus – im Unternehmensjargon ‚Pavillons' genannt – nimmt Aufenthaltsbereiche und Cafeteria auf. Er ist durch zwei Brücken mit dem größeren Teil verbunden, dem Ausbildungs- und Ausstellungszentrum. Zwei diagonal gegeneinander versetzte Türme zu beiden Seiten der Flachbau-Pavillons enthalten Verwaltung und Albergo. Jeder der beiden Türme wird von einem schlanken, über Eck gestellten Nottreppenhaus begleitet, das die obersten Normalgeschosse der Türme überragt. Noch höher hinaus – bis zu 54 und 51 Meter – führen die massiven Treppen- und Aufzugsanlagen, die in den beiden Türmen stecken und deren Kernzonen bilden.

Erweiterungsmöglichkeiten bestanden. Ein dritter Turm war angedacht, ebenso eine Verlängerung des Flachbaus um jeweils eine Konstruktionsachse.

In adherence to Olivetti's corporate philosophy, the commission foresaw—aside from administration, sales, and technical aftersales service—spaces for hospitality, information, and training: a lobby, an exhibition hall, auditoriums, conference and training rooms, a cafeteria, and a hotel with the inviting name of Albergo. The various functions, the approximately 350 employees, the 120 to 150 course participants, hotel guests, and visiting public generated an urban atmosphere on the long, narrow property in Niederrad, then a remote office district, though well connected by regional train and other transport infrastructure.

The final project has a divided, two-story block surrounded by open parking spaces. The smaller section of the flat, divided block—known as a pavilion in corporate jargon—contains lounge areas and a cafeteria. It is connected by two bridges to the larger section with the training center and exhibition hall. Two towers stand obliquely from one another on either side of the horizontal pavilions and house the administration and the Albergo. Each of the towers is accompanied by a separate slender, diagonally positioned emergency stairwell structure, which overtops the upper floor of the towers. The massive core blocks of each high-rise containing the stairwells and lifts extend even higher, up to 54 and 51 meters.

Options were foreseen for expansion. A third tower was conceived, as well as an extension of the pavilion by one construction axis on each side.

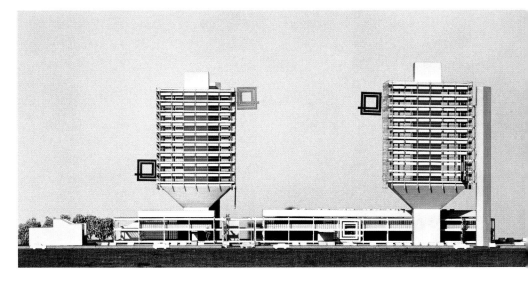

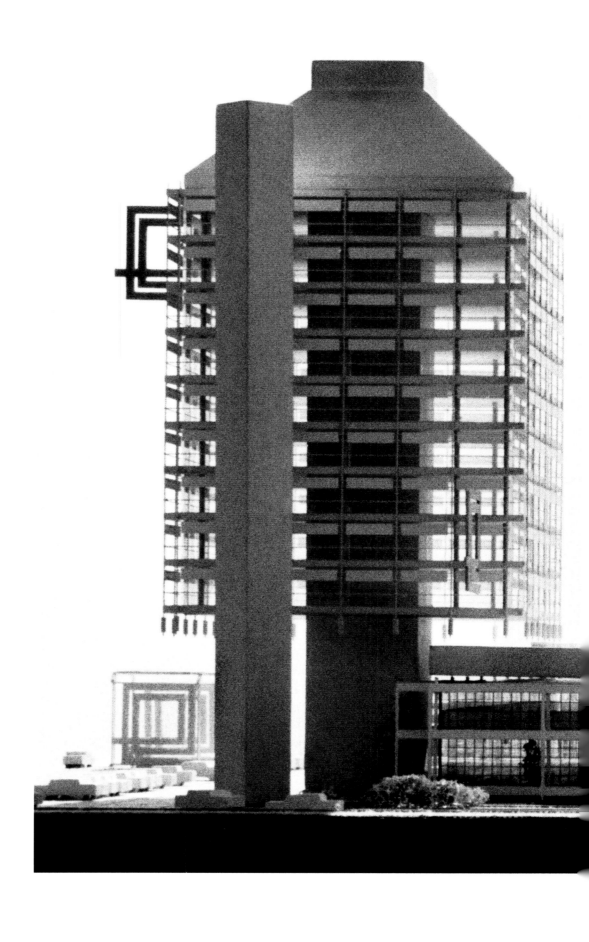

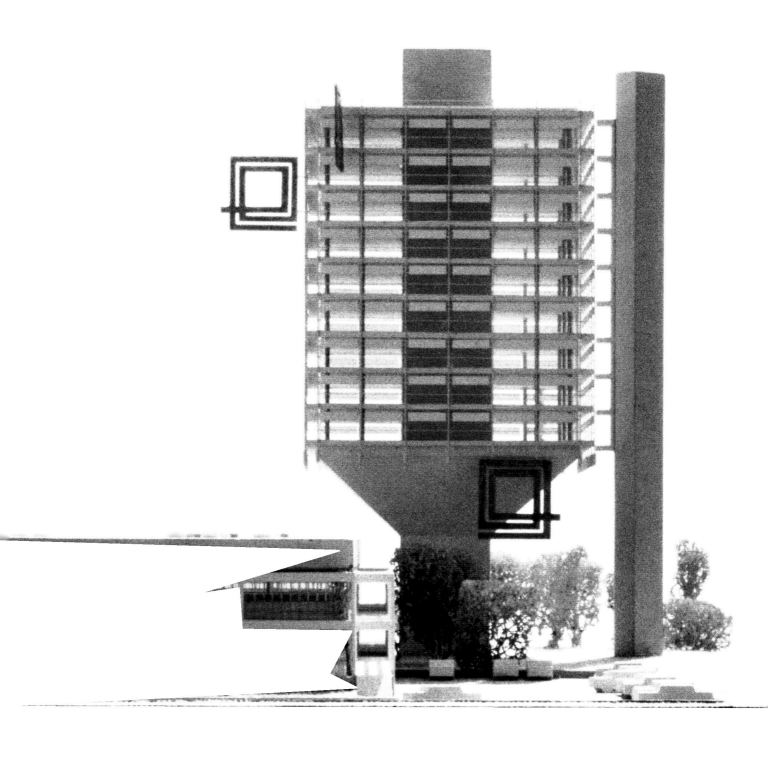

Zunächst sollte einer der Türme, eine Hängekonstruktion, eine Stumpfpyramide als Dachhaube tragen, der andere auf einem umgekehrt geformten Kelch sitzen. Es blieb bei Kelchen für beide Türme.

Initially one of the towers was to be crowned by a hanging construction of a flat pyramid as a roof hood, while the other was to sit on an inverse, so-called goblet-shaped form. Ultimately the goblet shape was employed for both towers.

Eiermann hatte Vorlieben für und Abneigungen gegen bestimmte Materialien. Er liebte den Stahl, dessen Präzision und federnde Eleganz. Von Anfang an hatte er die Zustimmung seiner Bauherren zu einem Musterbau des Stahls eingeholt. Dagegen befand er das verformbare Material des Betons als „beliebig", „verführerisch" und „gefährlich".[4] Für Eiermann war Beton plebejisch, ein schlammiges Gemisch, das erst durch Schalung Form und durch Stahleinlagen Zugfestigkeit erhält. So lag ihm auch beim Olivetti-Komplex in Niederrad am Eindruck eines schlanken, elastischen Stahlgebildes.

Tatsächlich aber hat auch der Beton großen Anteil. Abgesehen von Fundamenten, Deckenbelägen, Kernzonen und Teilen der tragenden Konstruktion spielt Stahlbeton auch für das Auge eine beträchtliche Rolle: bei den Kelchen, den in Gleitschalung gegossenen Turmstielen, den freistehenden Sicherheitstürmen. Dass man das Gefühl eines solide-verlässlichen Tragwerks bekommt, das den Kontrast zu den leichten stählernen und gläsernen Fassaden und Innenkonstruktionen erst möglich macht und ihren Reiz ausspielt, ist dem angeblich plebejischen Material Beton zu verdanken.

Stahl dagegen verband sich für Eiermann mit dem Gedanken der Vorläufigkeit. Was zusammenmontiert war, konnte auch wieder auseinandergenommen, weiterverwertet oder eingeschmolzen werden. Stahl war das noble, das aristokratische Material. Wurde es nicht mehr gebraucht, konnte man es in Würde verabschieden. Wer ein Haus baut, muss auch dessen Ende im Sinne haben. „Das, was wir bauen, erhebt gar nicht den Anspruch, altern zu wollen oder Patina anzusetzen, es verschleißt wie ein Automobil, es wird benutzt und nach gar nicht so viel Jahren – zumindest nicht so vielen Jahren wie früher – verschwindet es wieder. Es hat also nichts von Zeitlosem, sondern nach Sinn und Zweck ist es zeitlich bedingt".[5]

Eiermann had preferences for and an aversion to certain materials. He loved steel, its precision and elastic elegance. From the project's very beginning he had solicited permission from the client for an exemplary building made of steel. In contrast, Eiermann regarded the formable material of concrete as "arbitrary," "seductive," and "dangerous."[4] For him concrete was plebeian, a slimy mixture that only acquired its shape through formwork and its tensile strength through reinforcing steel. For the Olivetti complex in Niederrad he thus envisioned a slender, elastic steel structure.

In fact, however, concrete is crucially present in the building. Aside from the foundations, ceiling covering, core zones, and parts of the load-bearing construction, reinforced steel concrete is visibly and prominently present: in the goblets, in the towers' shafts made in slipform, in the free-standing emergency stairwells. That one has the feeling of a solid and steadfast frame, which allows the contrast to—and plays off against—the light steel-and-glass facade and the internal construction, is thanks to the supposedly plebeian material of concrete.

Steel, on the other hand, was linked for Eiermann with the idea of transitoriness. What could be mounted together could also be dismounted, reused, or melted down. Steel was the noble, aristocratic material. When it was not needed anymore, one could bid it farewell with dignity. Whoever builds a house, has to also think of its end. "What we build does not claim at all to get older or acquire the patina of age, it gets worn out like an automobile, it is used, and after not too many years—at least not as many years as before—it disappears again. It does not possess timelessness, but rather it is temporally determined, according to its meaning and purpose."[5]

4 Egon Eiermann an/to Wilhelm Künzel, Düsseldorf, 1.12.1964. Briefe, a.a.O./op. cit., S./p. 181.
5 Egon Eiermann an/to Hans Gerber, 22.6.1951. Briefe, a.a.O./op. cit., S./p. 24.

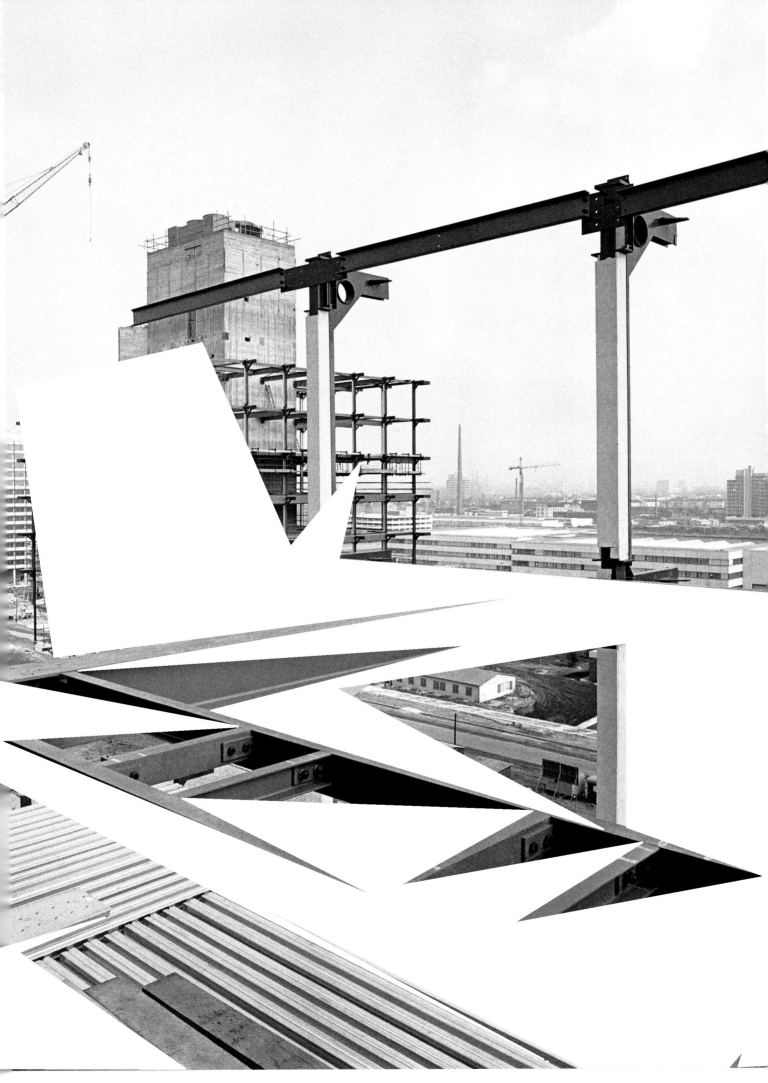

Eiermann baute die Fassaden in mehreren Schichten auf. Um das Innere laufen offene Umgänge, die er funktional begründete wie fast alle seine Formentscheidungen: als Rettungswege, als Reparaturgänge, die im Bedarfsfall Baugerüste ersparen, zur Fensterreinigung, gegen Schlagregen. Deren Konsolen sind wie alle Stahlteile graublau gestrichen, tragen aber helle Betonfertigteile als Umgangsplatten. Weiß gestrichen ist das Stabwerk der vertikalen und horizontalen Profile. Eckjoche der Flachbauten sind durch diagonale Windverbände ausgesteift. Auf allen vier Seiten, auch denen ohne Sonneneinfall, wurden schräg gestellte Segeltuchblenden montiert. Bei starker Hitze sollten sie den Luftkreislauf an der Fassade fördern und Blendung vermeiden.

Die Details suggerieren maritimen Charakter: Gangway, Reling, Segel. Der Auftraggeber verglich sie mit einem „voll getakelten Segelschiff".[6]

Eiermann built up the facade in several layers. Open walkways encircle the inner building, which he justified functionally, like almost all of his formal decisions: as emergency escape routes, as access for repairs, thus obviating scaffolding, for cleaning windows, protecting against driving rain. The walkways' brackets are like all the steel components painted gray-blue, but support the bright, prefabricated concrete plates of the walkway. The vertical and horizontal profiles of the framework are painted white. The corner bays of the pavilions are reinforced by diagonal wind bracing. On all four sides, including those without direct sunlight, oblique sailcloth shutters were mounted. When temperatures are high they promote air circulation along the facades and avoid blinding direct sunlight.

The details suggest a marine character: gangway, rails, sails. The client compared them with a "fully rigged sailing ship."[6]

6 Olivetti Presse Informationen, a.a.O./*op. cit.*

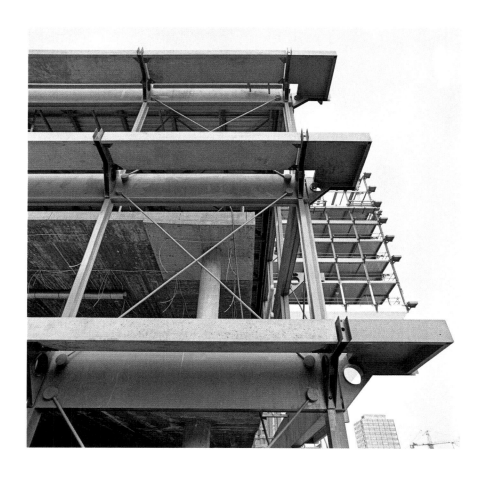

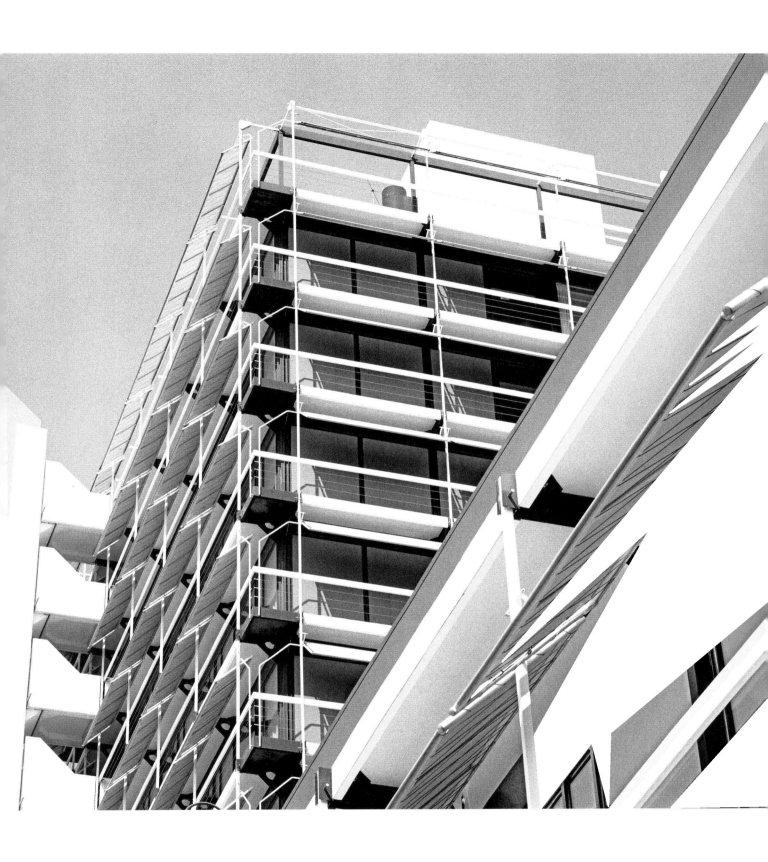

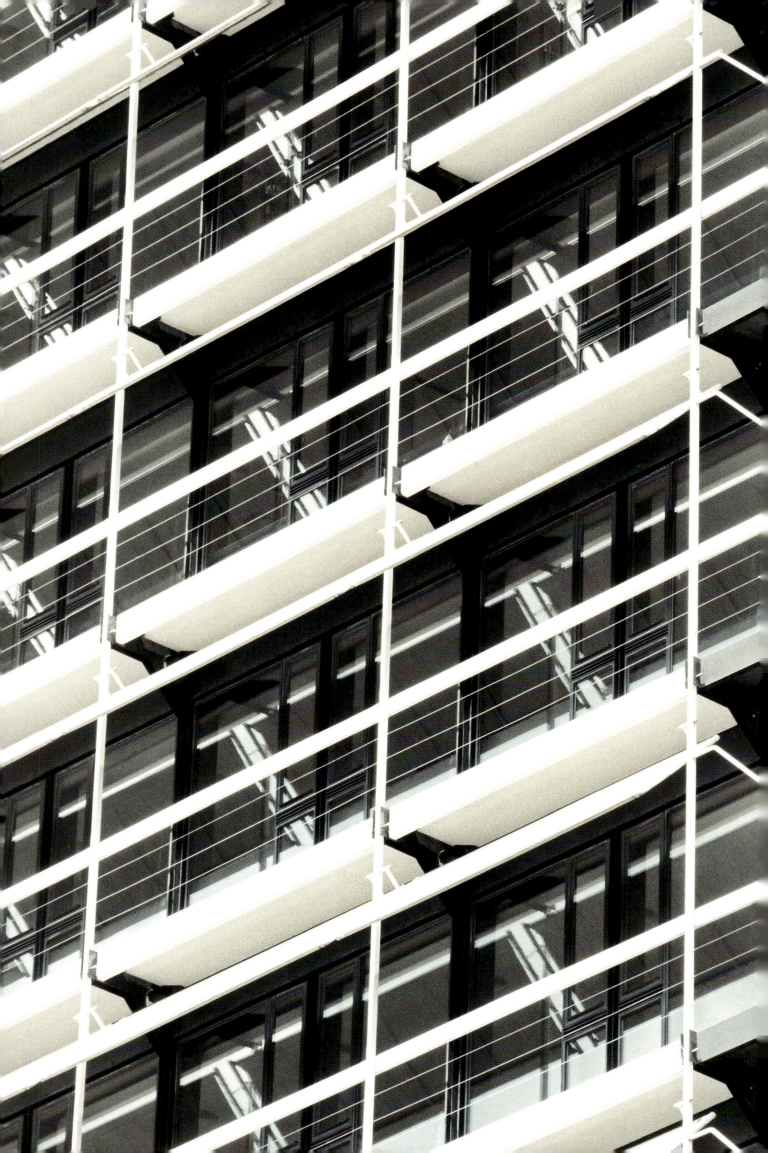

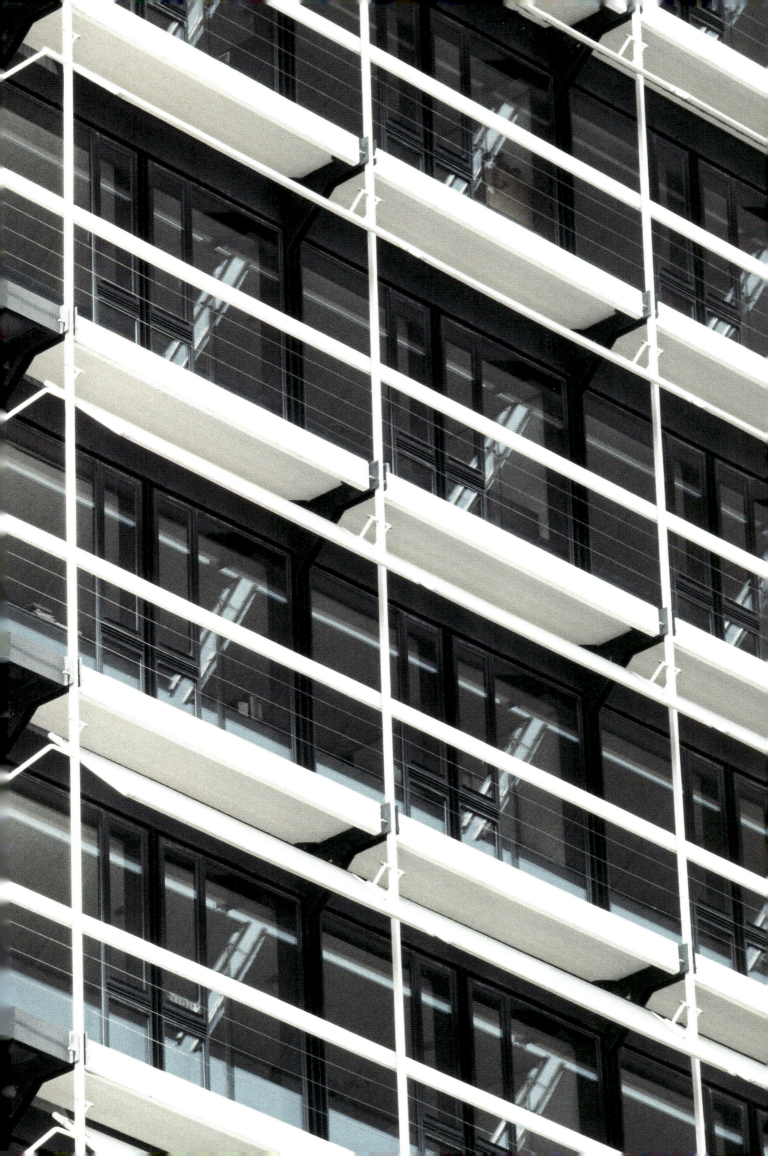

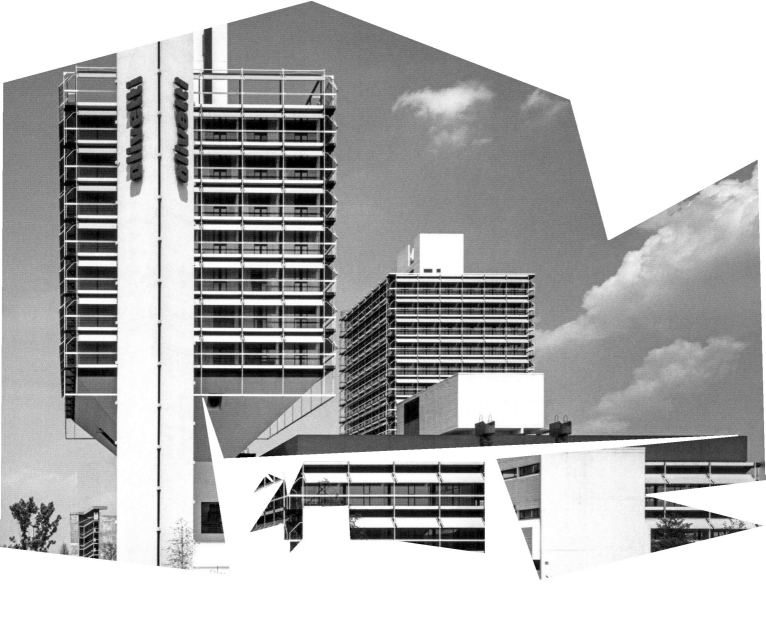

Blick von Süden, links der Hotelturm, rechts Cafeteria mit Anbau und Dachaufbau für die Haustechnik, hinten der Verwaltungsturm. Eiermann hielt sich nicht strikt an Symmetrie. Der kleinere Turm markiert mit einer stählernen Pergola ein Luftgeschoss, über das sein neungeschossiger Zwilling nicht verfügt. Einer der ersten Rezensenten des Gebäudes sprach von „irritierender Verschiedenheit".[7]

View from the south: on the left, the hotel tower; on the right, the cafeteria with annex and roof structure for building services. Eiermann was not strictly symmetrical. A steel pergola delineates an open story on the smaller tower that is missing on its nine-story twin. One of the first reviewers of the complex spoke of this "irritating difference."[7]

7 Eberhard Schulz: Die Kelche von Olivetti. In: Stahl und Form, a.a.O./op. cit., S./p. 4.

Normalgeschoss-Grundriss der Hochhäuser, links Hotel ‚Albergo', rechts Verwaltung mit Dachaufsicht der Flachbauten.

General floor plan of the towers: on the left, the hotel; on the right, the office tower with a view of the pavilion's roofs.

Grundriss Erdgeschoss, links der kleinere Teil des Flachbaus mit Empfangshalle, Freizeitbereich für Gäste und Zugang zum Hochhaus des Hotels, rechts der größere Teil des Flachbaus mit Ausbildungszentrum und Zugang zum Büroturm.

Ground floor plan, on the left the small unit of the pavilion with lobby, lounge areas for guests and access to the hotel, on the right the large unit with training center and access to the office tower.

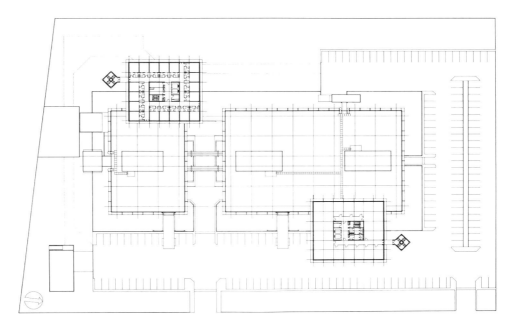

0 5 10 m

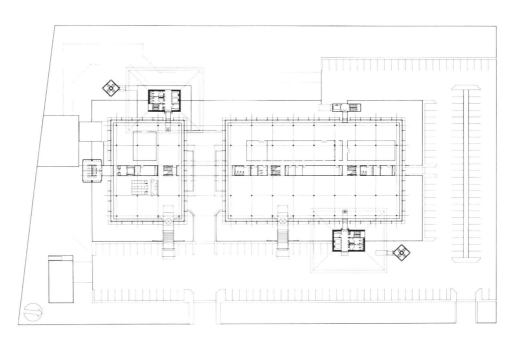

Schnitt und Ansicht in der ausgeführten Fassung mit zwei Kelchtürmen.

In der Werbung des Unternehmens löste der von dem schweizerisch-italienischen Grafiker Walter Ballmer entworfene Schriftzug ‚Olivetti'[8] 1971 das Logo der ‚griechischen Spirale' ab, das der italienische Designer Marcello Nizzoli 1954 entwickelt hatte [Abb. Seiten 4/5].

8 http://www.storiaolivetti.it

Section and view of the executed version with two goblet towers.

In 1971 the Olivetti logo[8] created by the Swiss-Italian graphic artist Walter Ballmer replaced the "Greek spiral," developed by the Italian designer Marcello Nizzoli in 1954, in the firm's publicity [fig. pages 4–5].

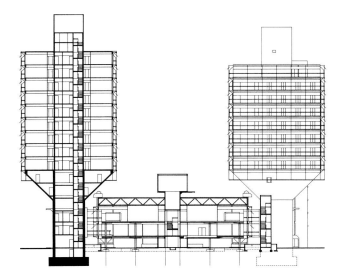

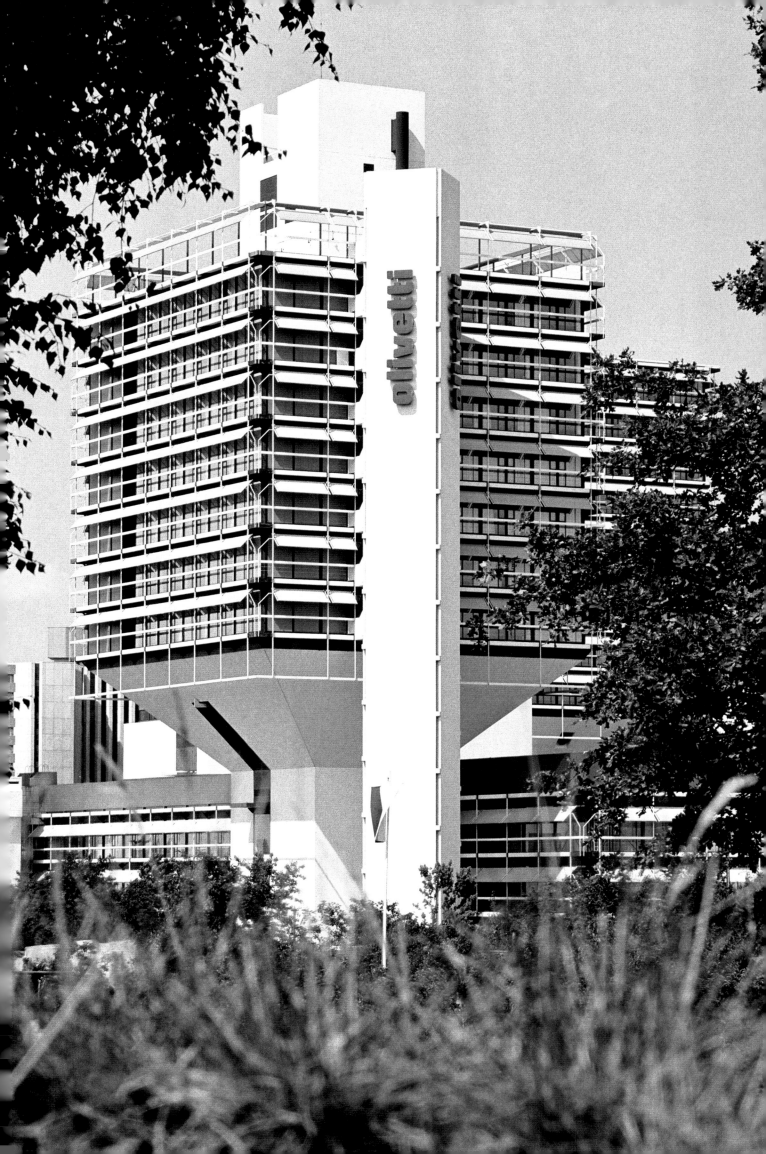

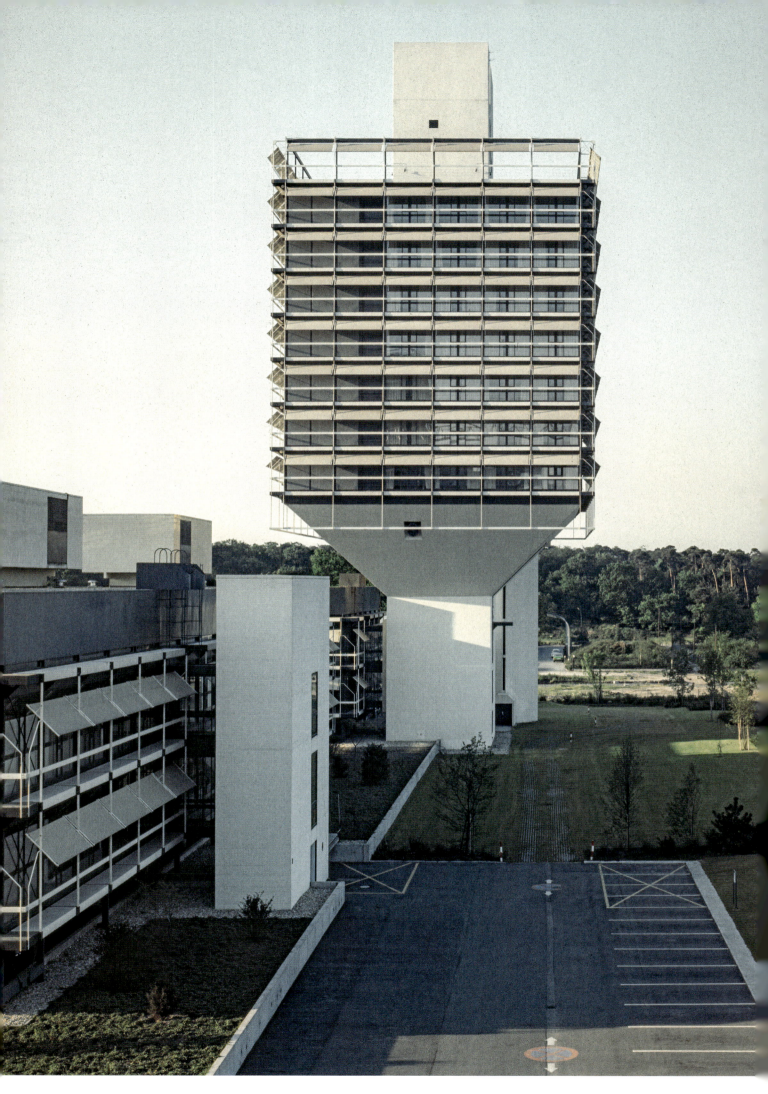

Renzo Zorzi, Direktor für kulturelle Beziehungen bei Olivetti, beschrieb seine Begegnung mit Eiermann an dessen Karlsruher Lehrstuhl: „Es war einer der intensivsten, wärmsten und glücklichsten Tage, an denen man endlich für seinen Beruf dankbar ist … Er (Eiermann) begeisterte sich sofort für das Projekt, er hatte eine Wärme, einen Wunsch nach Gefallen, eine Unmittelbarkeit der Ideen, die überzeugten. Er setzte sich an den Zeichentisch und skizzierte einen ersten Entwurf der beiden Türme, die Bureaus und das Appartement-Haus, die dann im Endprojekt blieben … Er steckte einen Enthusiasmus und eine Überzeugung in die Sache, als ob wir sein erster Kunde gewesen wären … Als wir uns trennten, waren wir über jedes Detail einig. Als er mich zum Ausgang begleitete, wurde er für einen Augenblick schweigsam, und indem er in seinem starken, lebhaften Gesicht, das vom Kranz kurzer völlig weißer Haare freundlicher gemacht wurde und weicher wie regungslos erschien, die Lippen zusammenpresste, nahm er meine beiden Hände und sagte ‚Das ist mein letztes Werk. Eine Art Testament.'"[9]

Renzo Zorzi, director for cultural affairs at Olivetti, described his encounter with Eiermann at the university in Karlsruhe: "It was one of the most intensive, warmest, and happiest days, when you are finally thankful for your job. … [Eiermann] was immediately enthusiastic for the project, he had a warmth, a wish to please, an immediacy of ideas that were all captivating. He sat down at his drawing board and sketched out a first draft of the two towers, the offices, and the apartment building, which ultimately remained in the final project. … He put so much enthusiasm and persuasion into it, as though we were his very first clients. … Before I left we had agreed on every detail. When he accompanied me to the exit he became silent for a moment; his strong, lively face, made friendlier by a wreath of short, completely white hair, became softer and impassive, he pressed his lips together, took both of my hands, and said: 'this will be my last work. A kind of testament.'"[9]

9 Renzo Zorzi: Begegnung mit Egon Eiermann. In: Bauwelt, 1972, Heft/*issue* 13, S./*p.* 513.

Hotelturm von Norden. Das weiß gestrichene Fassadengerüst ist über den Kelchrand herunter- und über die Dachkante hinaufgezogen und betont so seinen nicht tragenden Charakter.

Hotel tower from the north: The framework over the facade painted white is extended both below the edge of the goblet base and over the roof edge, emphasizing its non-load-bearing character.

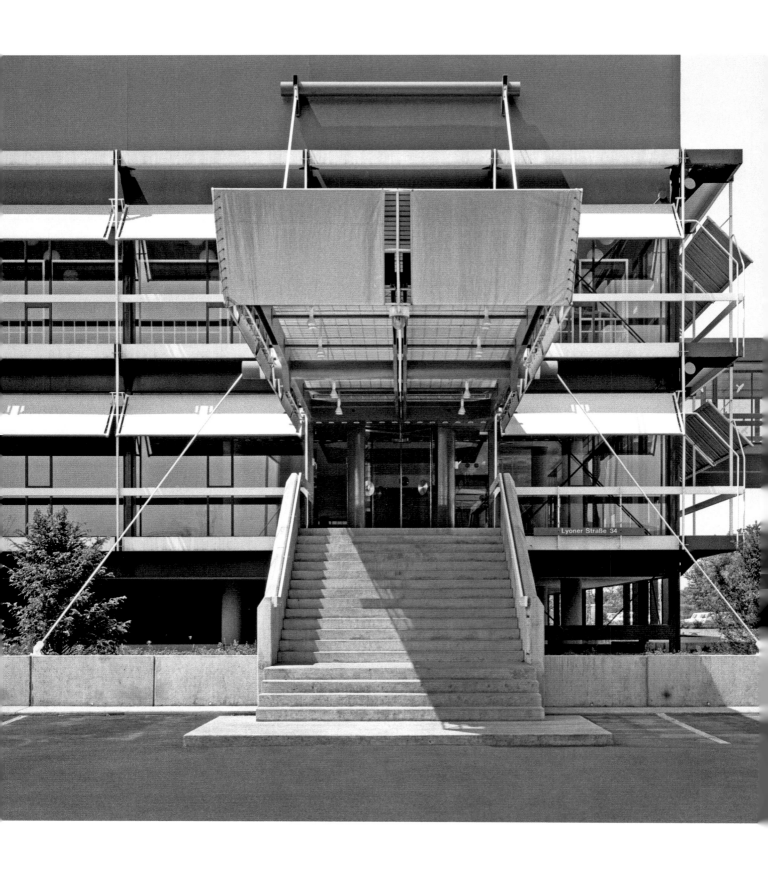

Eiermann legte Wert auf eine möglichst berührungsfreie Verdeutlichung aller einzelnen Elemente. Dieses „Noli me tangere"-Gebot gilt bereits bei der Massenkomposition. Die Kelchtürme wachsen nicht aus dem Flachbau heraus, sondern sind von ihm freigestellt. Ihre durch die Kelchform bedingte Auskragung beschirmt nur wenige Quadratmeter des Flachbaudaches. Einen Höhepunkt erreicht die Diskretion, bei der das eine das andere nur wie mit Fingerspitzen berührt, bei den Vordächern über den beiden Haupteingängen. Zwölf Meter schnellt der stählerne Hohlkasten der Vordachkonstruktion vor und muss ob dieser Kühnheit von diagonalen Abspannstangen und Zugseilen gehalten werden.

Eiermann valued the exposition of each individual element with as little contact as possible. This principle of "noli me tangere" already applies to the composition of masses. The goblet towers do not grow out of the pavilions, but are instead separately positioned. Their inverted pyramid shape produces an overhang that nevertheless only shadows a few square meters of the pavilion roof. The discretion reaches a high point where one element touches another as with fingertips, in the canopies over the main entrances. Their hollow steel rectangle construction juts out twelve meters from the pavilion; this daring gesture requires that they be supported by diagonal braces and cables.

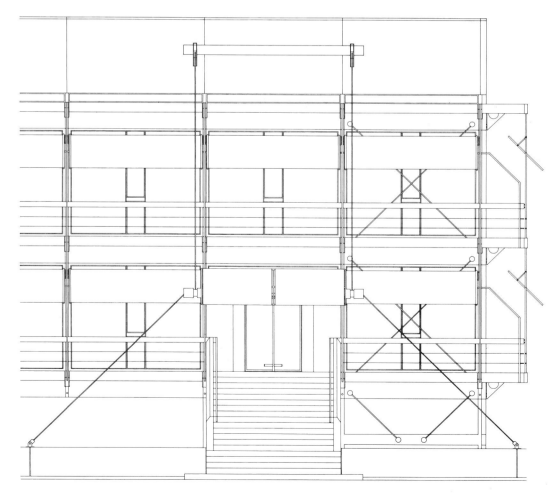

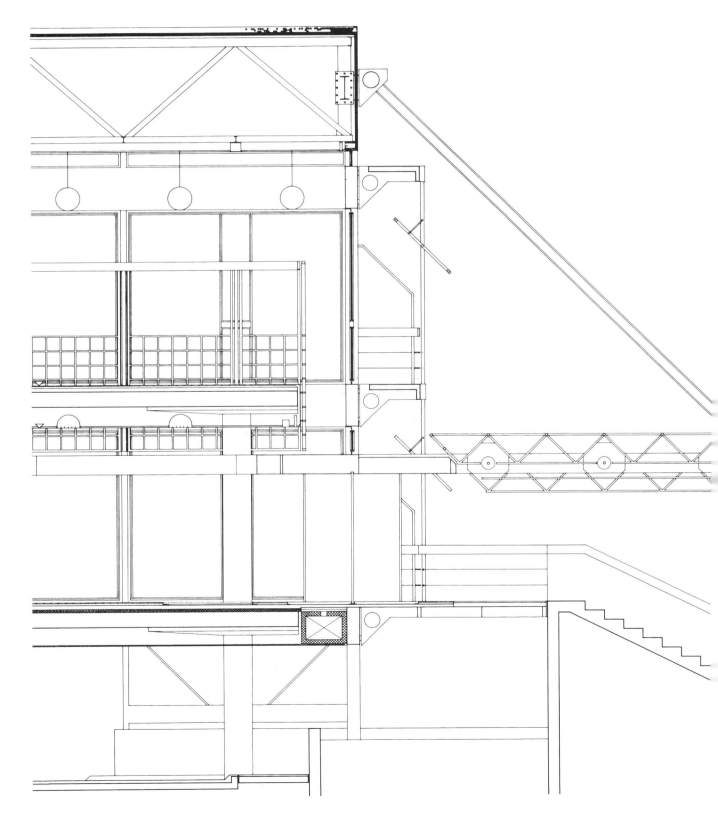

Schnitt durch den Eingang zu Cafeteria und Hotel mit Zugseilen und Abspannstangen, die das weit vorspringende Vordach halten.

Section through the entrance to cafeteria and hotel, with cables and braces holding the canopy protruding far forward.

Grundriss des Eingangs Cafeteria und Hotel

Drehtür mit seitlichen Fluchttüren, Eingangspodest und Treppenaufgang. Seitlich verlaufen die Zugstangen des Vordachs, eines Hohlkastenrahmens, der mit Segeltuch bespannt war.

Floor plan of the entrance Cafeteria and hotel

Revolving door with lateral emergency exits, entrance platform, and stairs. The canopy is supported by lateral braces and is a hollow container, originally covered with sailcloth.

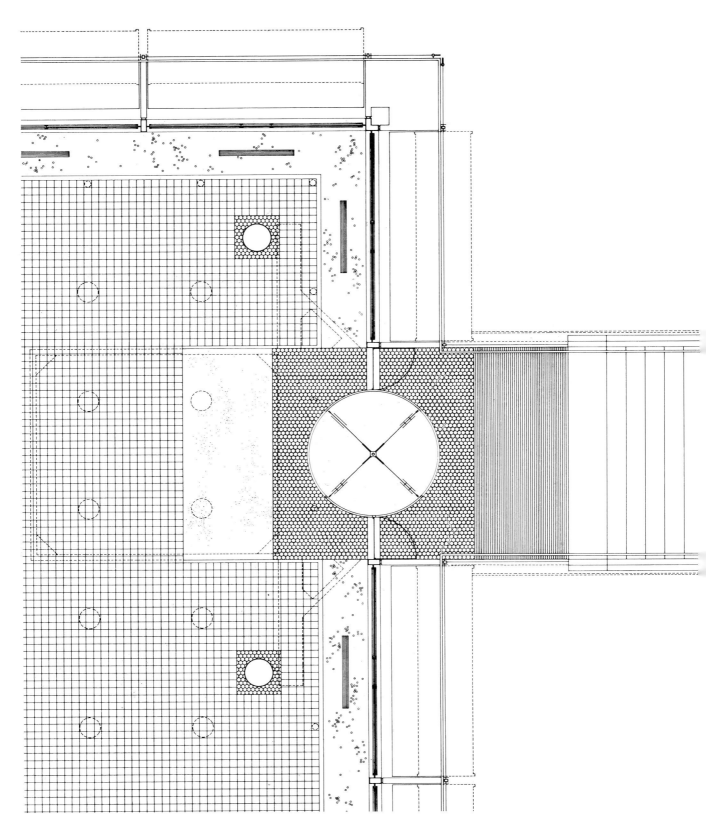

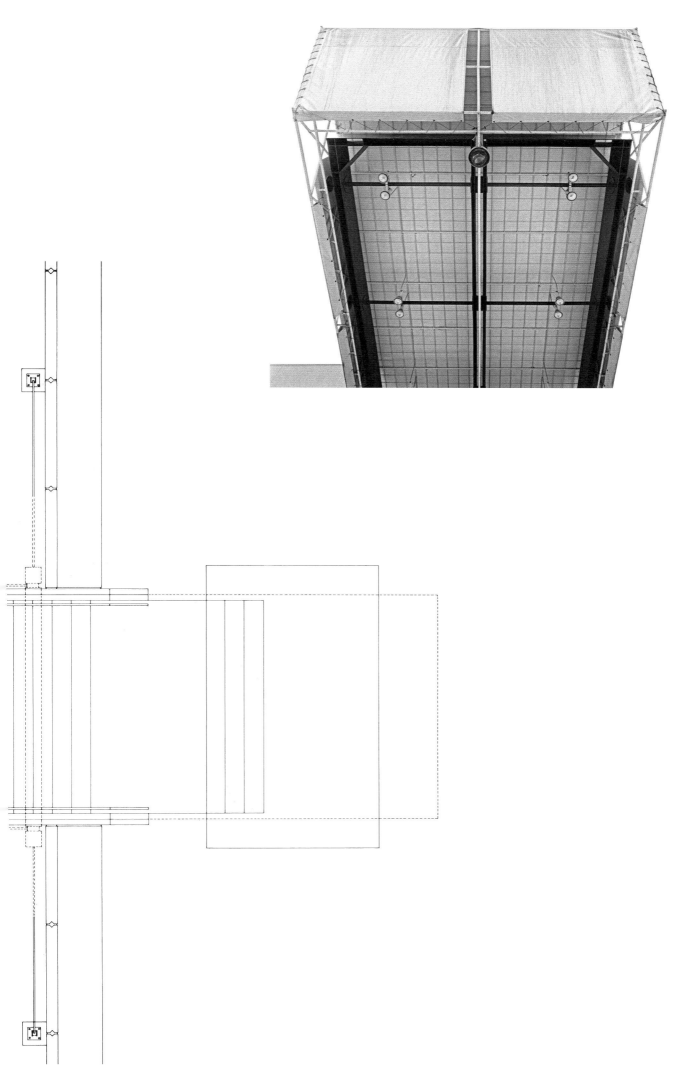

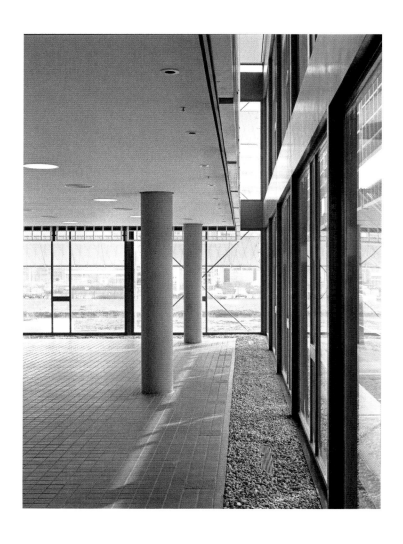

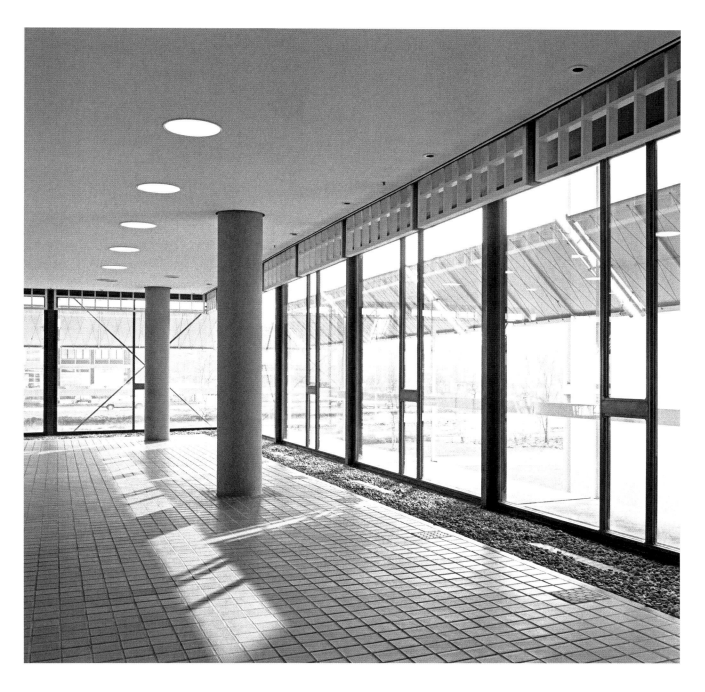

| Ebene Erdgeschoss im Zugangsbereich zu Cafeteria und Hotel. | Ground-floor level in the entrance area to the cafeteria and hotel. |

Die Devise „Rühr mich nicht an" galt auch für die Raumaufteilung. Der Aufenthalts- und Freizeitbereich hielt Abstand von der Fensterwand und bildete eine Art Haus im Haus. Zwischen Fensterwand und Bodenfliesen lief ein Kiesstreifen mit Auslässen der Belüftung – im Gebrauch problematisch, da der Aufwind Staub aus dem Kiesbett wirbelte. Vor den Glasscheiben verliefen oben zwei Reihen des Holzgitters, das sich im Obergeschoss als Brüstungsgitter fortsetzte.

The principle of "noli me tangere" also applies to the distribution of rooms. The lounge and recreational area was separated from the curtain wall and formed a type of building within a building. A strip of gravel, with openings for ventilation ducts, ran between the curtain wall and the floor tiles—in practice it was problematic, since the current from the ducts whirled up dust from the gravel. Above, at the top of the glass panes, were two rows of the wood lattice which continued on the top floor as a balustrade.

„Denn bei diesem Bau bin ich einzig und allein an der letzten Perfektion gedanklicher wie sachlicher Art interessiert. Das ist eine Einstellung, die heutzutage im Zeitalter der sogenannten Rationalisierung nicht mehr opportun ist, und unter deren Folgen alle zu leiden haben. Auch Sie, auch ich, wobei ich nur hoffe, dass die Erwartungen, die wir für diesen Bau empfinden, trotz aller Mühsal einen Lohn bringen können, der für unser Leben und für unsere gemeinsame Tätigkeit nicht ohne Bedeutung sein wird," schrieb Eiermann an seinen Mitarbeiter Rudolf Wiest.[10]

10 Egon Eiermann an/*to* Rudolf Wiest, 3.4.1970, Archiv saai, Karlsruhe.

"For with this building I am solely interested in ultimate perfection, theoretically as well as practically. This is an attitude that nowadays, in an age of so-called rationalization, is no longer opportune and under whose consequences we all suffer. You too, and me as well, although I can only hope that the expectations we have for this building will bring us a reward, despite all of the efforts, that will not be insignificant for our lives and for our joint activity," wrote Eiermann to his employee Rudolf Wiest.[10]

Treppe zum großen Speisesaal der Cafeteria

Stairs to the large dining room of the cafeteria

Cafeteria

Eiermann war auch auf kleinste Details bedacht: „Ich entdecke bei meinen Herren gewisse Tendenzen, so eine deutsche Sauerkraut- und entsprechende sächsische Kaffeeküche bei Ihnen einzubauen. Bevor das passiert, möchte ich gern von Ihnen eine grundsätzliche Stellungnahme, 1. dass zum Frühstück auch gegrillte Gerichte gereicht werden, d. h. also nicht gekochte Würstchen, sondern gegrillte Würstchen zum Beispiel, und 2. dass nicht dünner Kaffee, in Maschinen aus Geislingen an der Steige hergestellt, der morgens gebrüht und nachmittags um 4 dann ausgeschenkt wird, sondern dass eine anständige und leistungsfähige Espresso-Maschine aufgestellt wird."[11]

11 Egon Eiermann an/*to* Winfried Hoffmann, Projektleiter/*Project Architect* Neubau Deutsche Olivetti, 12.8.1969, Archiv saai, Karlsruhe.

Cafeteria

Eiermann paid attention to even the tiniest details: "I have discovered among the gentlemen a certain tendency to install a German sauerkraut kitchen with the corresponding Saxon coffee. Before this happens, I would like to have a statement of principles from you: 1. That grilled dishes will be served for breakfast, that is, not boiled sausages, but, for example, grilled sausages. 2. That instead of serving diluted coffee, brewed in machines from the town of Geislingen an der Steige, prepared in the morning and then served at four in the afternoon, a proper and high-performance espresso machine is installed."[11]

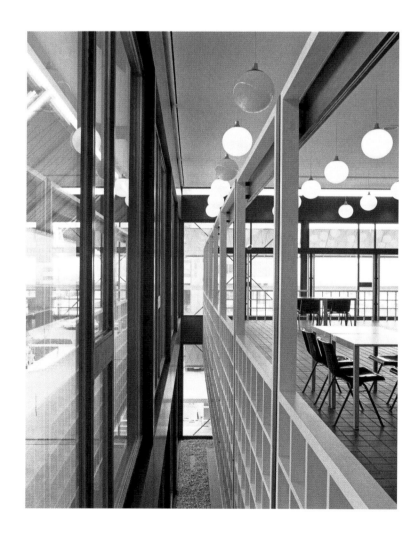

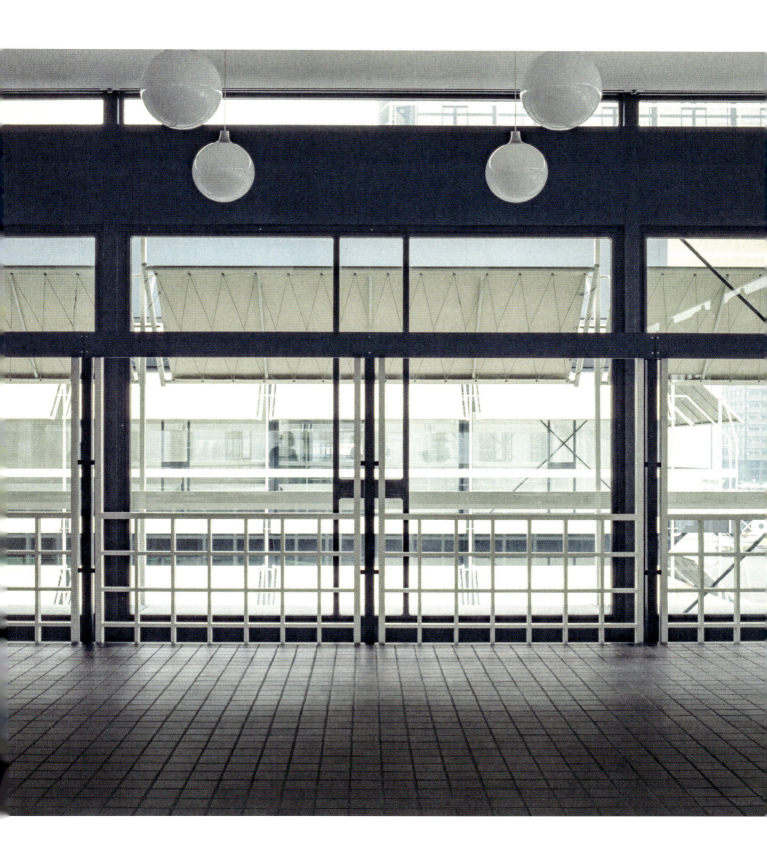

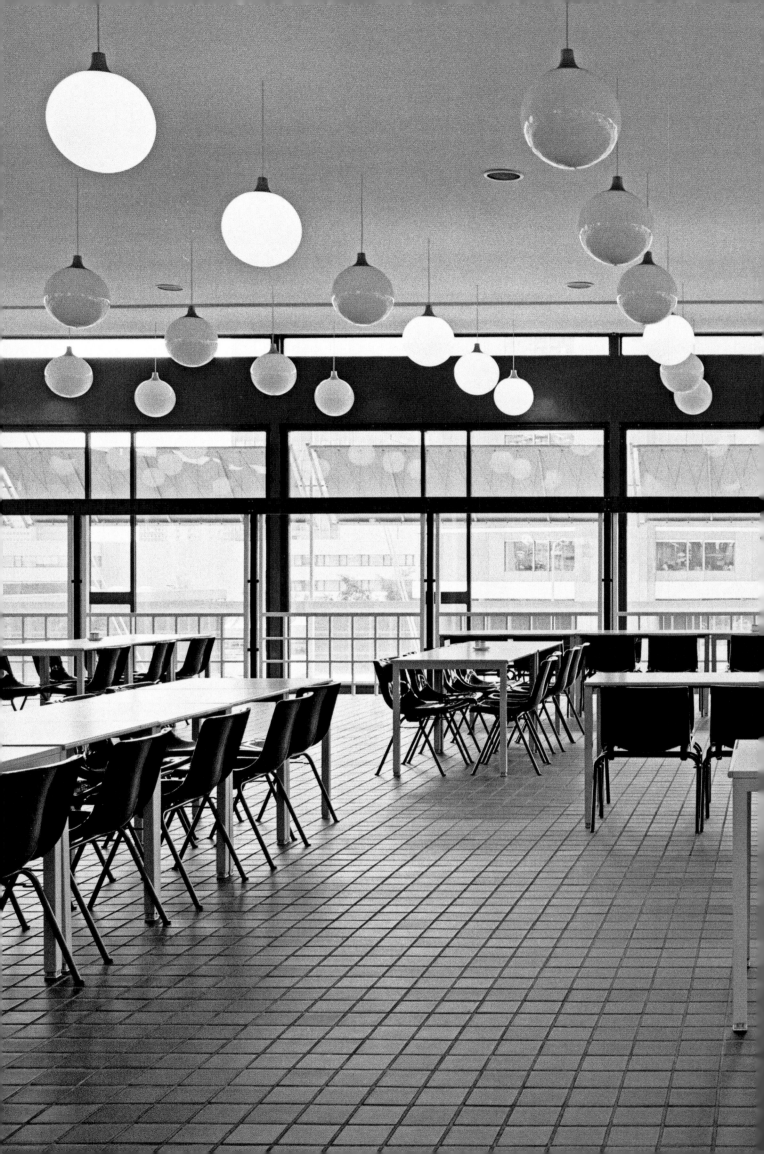

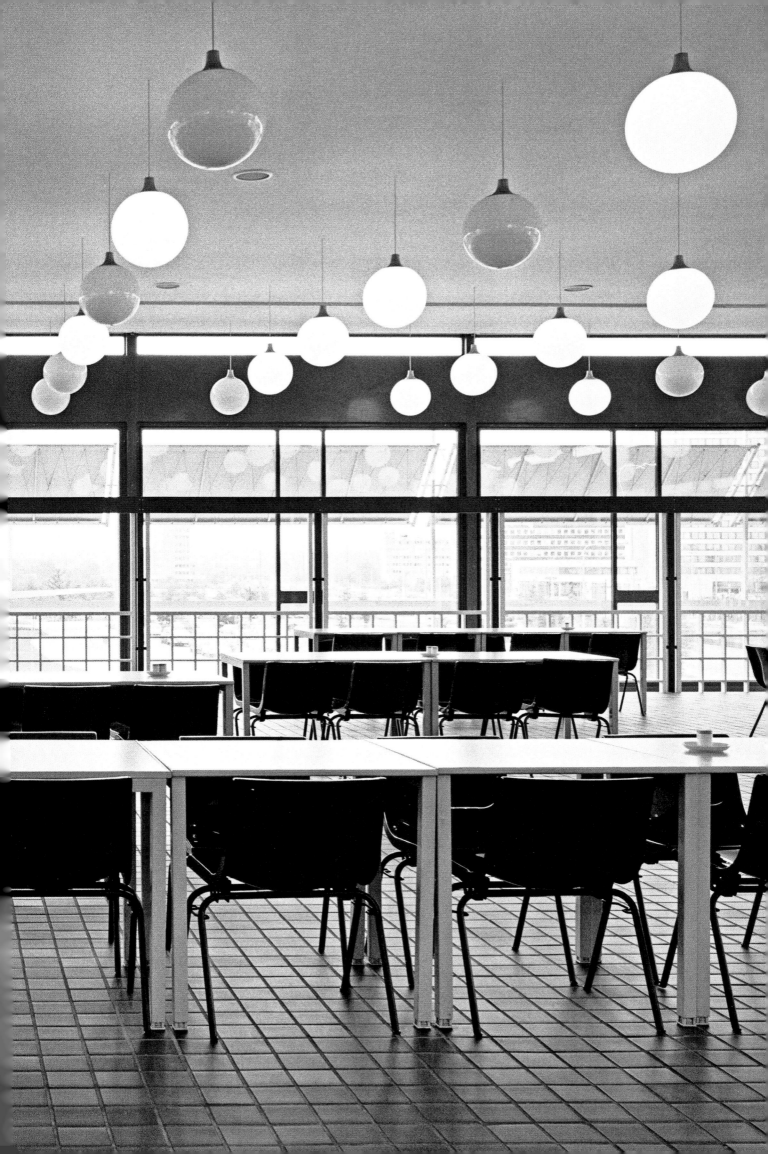

Sonnensegel vor den Gästezimmern des Hotelturms, offener Umgang mit Brücken zum Sicherheitstreppenhaus.

Im Widerspruch zu seinen originellen Lösungen bestand Eiermann auf dem Normcharakter seiner Formen: „Ich möchte ausdrücklich betonen, dass mir nicht an einer Architektur liegt, die durch ständige Produktion von Neuheiten und Überraschungen Sensationen hervorzurufen sucht. Meine Arbeit besteht darin, bestimmte Erfahrungen und Kenntnisse, die ich im Laufe meiner Arbeit gesammelt habe, als Standard, d. h. mit dem Begriff der Allgemeingültigkeit versehen, weiter zu entwickeln und sie zur Vollendung zu bringen, die Experimente ausschließt."[12]

12 Egon Eiermann an/*to* Carl Mertz, Präsident der Bundesbaudirektion, 10.4.1961, Archiv saai, Karlsruhe.

Awning in front of the guest rooms in the hotel tower, open walkway with bridge to emergency stairwell.

In contrast to his original solutions, Eiermann insisted on the standardizing character of his forms: "I would like to clearly emphasize that I am not interested in an architecture that seeks to cause sensation through the constant production of innovations and surprises. My work lies in further evolving and perfecting certain experiences and knowledge, which I have collected in the course of my career, as standards, that is, to make them universal, excluding experiments."[12]

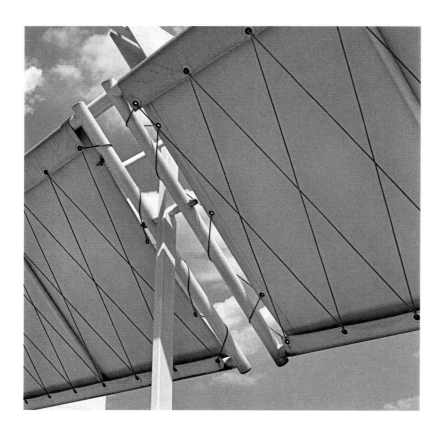

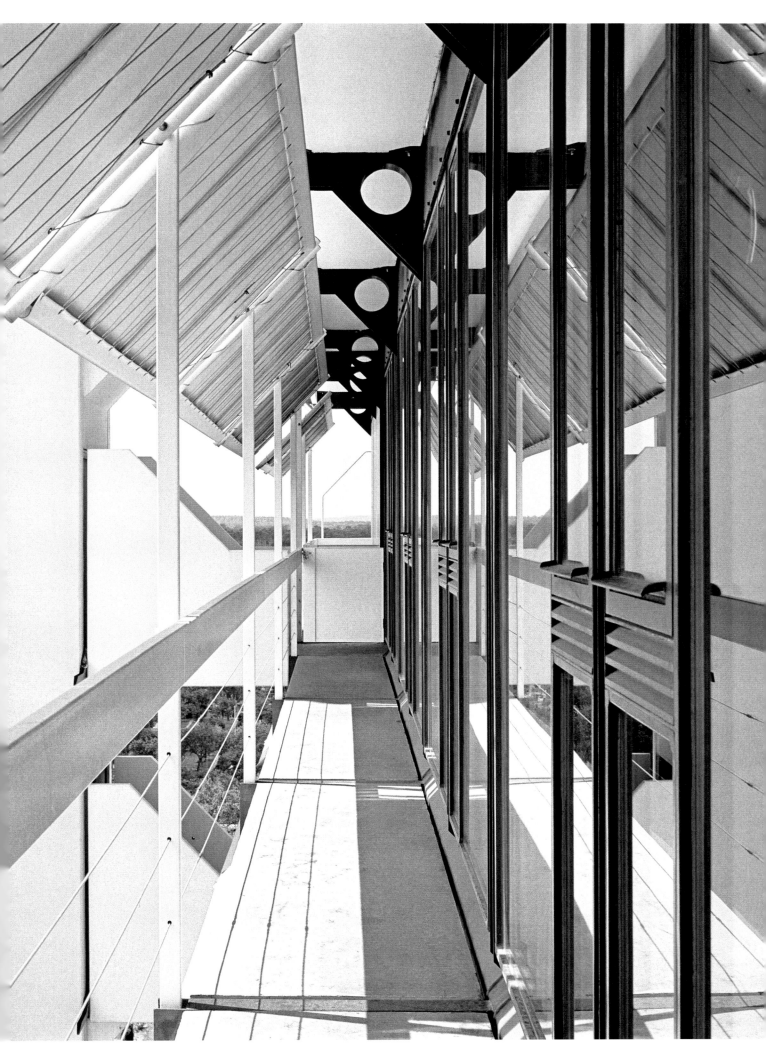

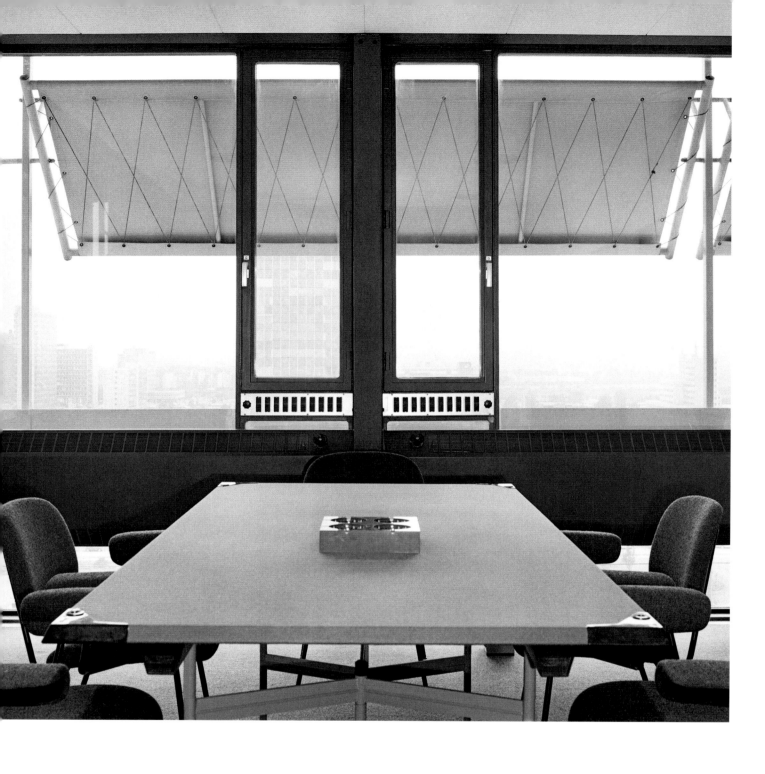

In den Hotelzimmern wie in den Büroräumen der Türme vermittelt der mehrschichtige Aufbau der Fassade den Eindruck, geschützt zu sein, bei gleichzeitiger Öffnung zur Außenwelt. Die Drehflügelfenster sind einander paarweise zugeordnet. Die Lüftungslamellen unter ihnen dienen der Dauerlüftung. Die Verglasung unterhalb des Konvektorenbandes, das in Brüstungshöhe angebracht ist, lässt Tageslicht auch noch in Bodenhöhe ein.

In the hotel rooms and offices of the towers, the multilayered construction of the facade gives the impression of being protected, and at the same time open to the world. The pivot windows are arranged in pairs. The ventilation grids under them provide constant air circulation. The glazing under the strip of the convection heater, which is positioned at railing height, provides daylight at floor level, too.

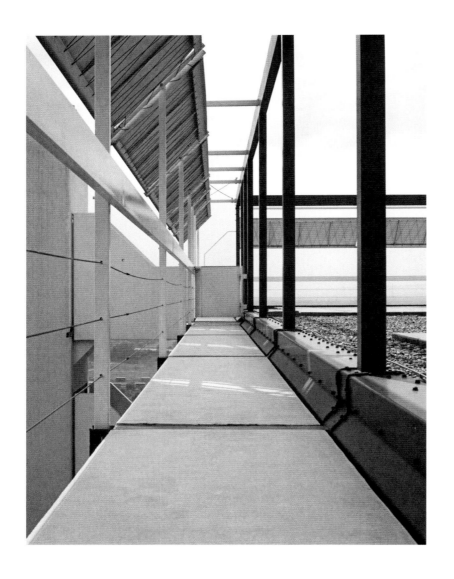

Am siebenstöckigen Hotelturm führte Eiermann das filigrane Fassadengestänge über das oberste Geschoss hinaus, so dass eine umgrenzte Terrasse entstand. Der Blick entlang des Umgangs zeigt die Fassadenschichten: weiß gestrichene senkrechte und waagrechte Stahlprofile, textile und geschnürte Sonnensegel im Winkel von 45° fest montiert, Laufgang aus Betontafeln, dunkle Stahlstützen mit umlaufendem Balken, Kiesstreifen. Links werden die Zugänge zum Sicherheitstreppenturm sichtbar. Auf der größeren Abbildung sind der Turmkern aus Beton und eine von Stahlblech ummantelte Revisionsleiter angeschnitten.

In the seven-story hotel tower Eiermann continued the filigree beams of the facade above the topmost story, creating a closed terrace. The view along the walkway shows the layers of the facade: vertical and horizontal steel profiles painted white, textile sailcloth shutters fastened at a 45° angle, a walkway made of concrete plates, dark steel beams with horizontal transoms spanning the facade, and gravel strips. On the left, access to the emergency stairwells is visible. The larger image below shows the tower's concrete core and a maintenance ladder covered in steel panels.

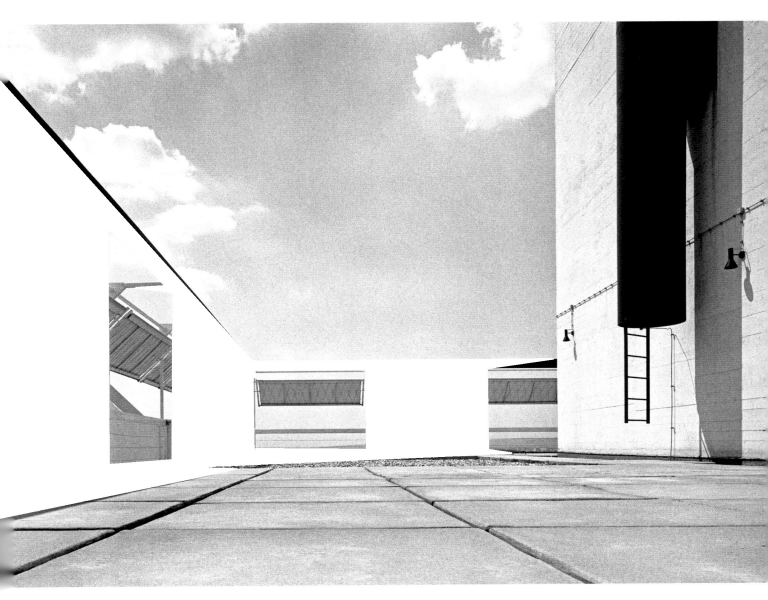

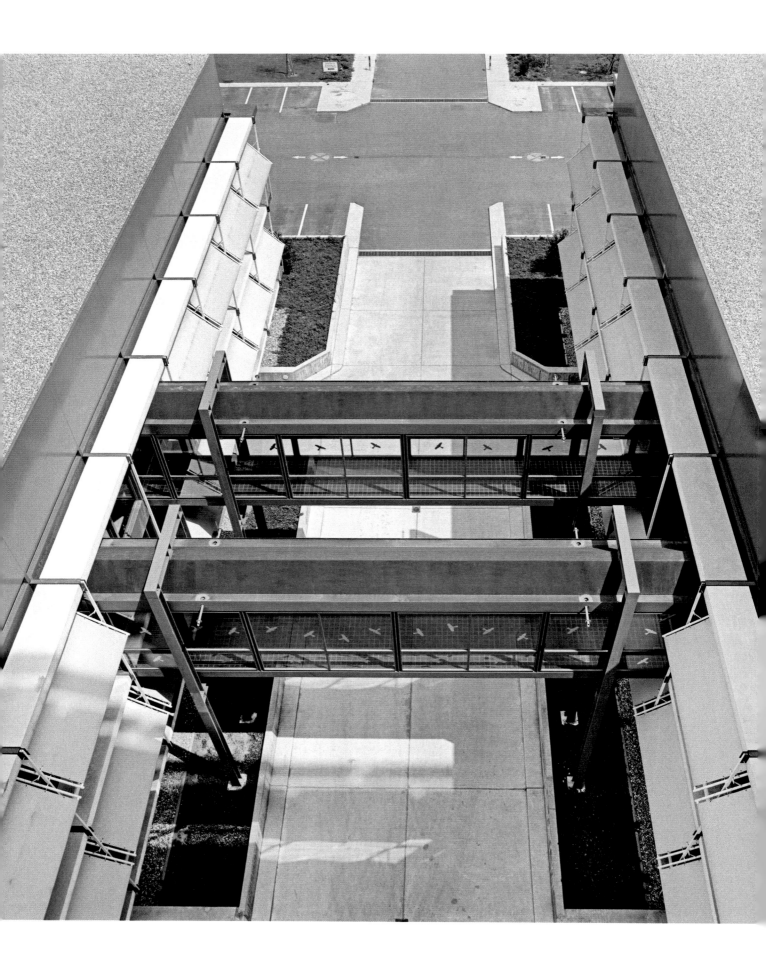

Verglaste Brücken, von Stahlrahmen-Paaren gehalten, verbinden das südliche flache Obergeschoss (Restaurant) mit dem nördlichen (Ausbildungs- und Verwaltungszentrum).

Austritte der Revisionsleitern führen auf das Flachdach des Ausbildungszentrums.
Der schmale Baukörper auf der linken, westlichen Seite enthält ein Treppenhaus und einen Lastenaufzug für An- und Auslieferung.

Glazed bridges supported by pairs of steel frames connect the southern flat upper floor (restaurant) with the northern training and administration center.

The maintenance ladders lead onto the flat roof of the training center.
The narrow building on the western left side contains a stairwell and a freight lift for deliveries.

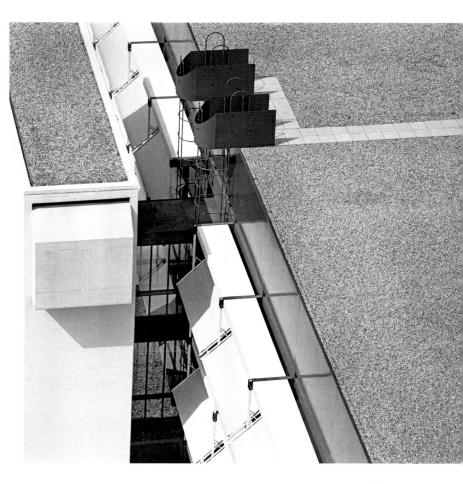

Eiermann glaubte an die Vereinbarkeit von Funktion, Wirtschaftlichkeit, Ästhetik und Moral: „Ich deute fast etwas Überflüssiges an, dass die Einführung eines gleichen Maßsystems zeitsparend ist, dass ein Bau, in dem die komplizierten Teile entfernt und zu besonderen Einheiten zusammengefasst sind und dessen Form dadurch seine Merkmale erhält, in schnellerem Zeitraum erstellt werden kann. Das bedeutet, dass Zeit ersparen Gestalt erzeugt.

Ich glaube, dass die Bilder zeigen, in welchem Maße ein nach solchen Ordnungen geplanter Bau Wandlungen höchster Eigenart zulässt.

Wir werden erkennen, dass in diesen Ordnungen die Logik, die Reinheit, die Klarheit, mit anderen Worten, der ethische Begriff der Wahrheit die entscheidende Rolle spielen. Wahrheit ist ein Bestandteil des Schönen, die Voraussetzung des Künstlerischen. So wird sich auf diesem Grund die neue, auf ökonomischen Gesetzen beruhende Architektur zur Kunst erheben."[13]

Eiermann believed in the fusion of function, economic efficiency, aesthetics, and morality: "I allude to something almost redundant when I say that the introduction of a unified measuring system saves time, that a building in which the complicated components have been eliminated and fused into special units, whose form acquires its characteristics in this manner, can be erected more quickly. This means that saving time creates form.

I believe that the pictures show to what extent a building planned according to such measurements can attain the greatest elegance.

We will recognize that in such measurements logic, purity, clarity, in other words, the ethical notions of truth, play decisive roles. Truth is a component of beauty, the precondition for what is artistic. In this manner the new architecture based on economic laws rises to become art."[13]

13 Egon Eiermann an/*to* Josef Neckermann, 19.3.1960. In: Briefe, a.a.O./*op. cit.,* S./*pp.* 167 f.

Haupteingang des Ausbildungs- und Verwaltungszentrums, dahinter der Hotelturm. Rechts vorne angeschnitten der Kern des östlichen (Verwaltungs-)Turms und die Untersicht des Kelchs.

Main entrance of the training and administration center, behind it the hotel tower. In front on the right a partial view of the core of the eastern (administration) tower and the bottom of the goblet.

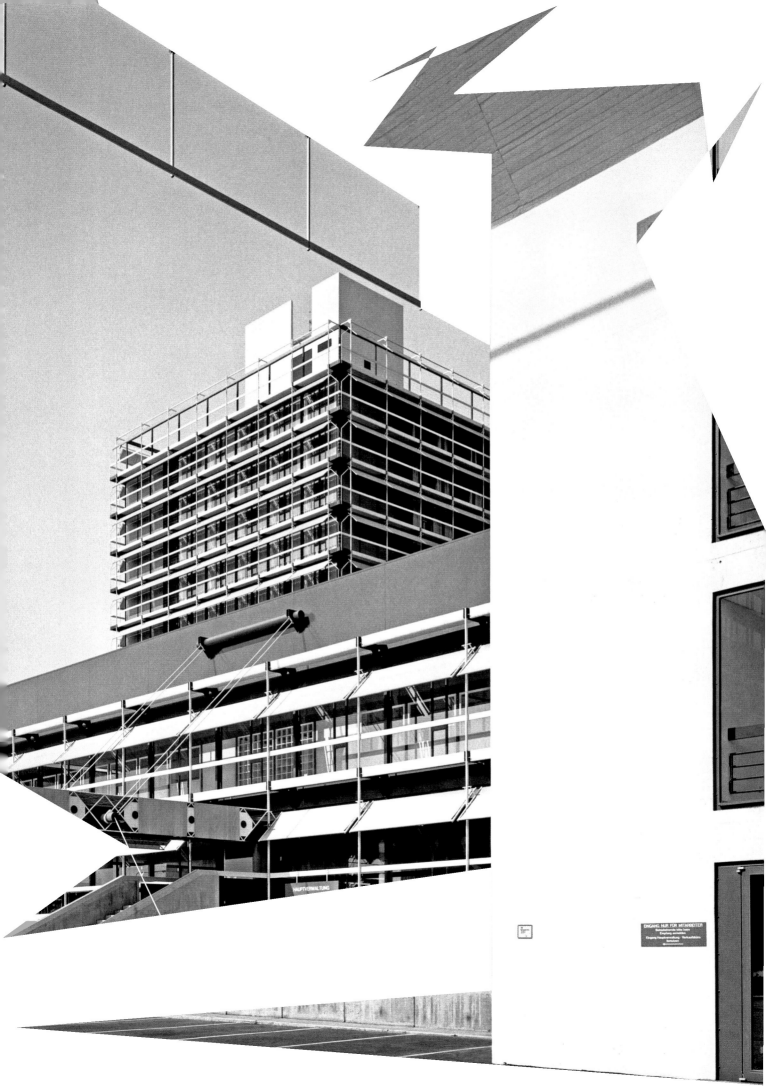

Arbeitsplatz und Sitzgruppe in der Eingangs- und Ausstellungshalle des Ausbildungszentrums.

Zellenartig geschlossene Räume sind vermieden, ausgenommen die vollklimatisierten Unterrichtsräume im Obergeschoss. Zum großzügigen Raumeindruck der Hallen trugen der durchgehende Fliesenbelag des Fußbodens und die geschosshohe Fensterverglasung bei. In beiden Flachbauteilen verläuft in Nord-Süd-Richtung ein mittlerer Bund, der Geschosstreppen, Toiletten, Haustechnik, sonstige Nebenräume sowie Ver- und Entsorgungsschächte zusammenfasst [vgl. S. 23].

Work space and seating group in the entrance area and exhibition hall of the training center.

Cell-like, closed rooms have been avoided, except for the fully climate-controlled classrooms in the upper story. The expansive spatial quality of the halls is achieved by uniform tiling of the floors and the fully glazed curtain walls. A central band runs through both pavilions in a north-south direction, containing the stairs, toilets, maintenance equipment, and other auxiliary rooms, as well as utility vaults and ducts [see page 23].

Eckbüro im Erdgeschoss des Ausbildungszentrums mit Blick auf den kleineren Teil des Flachbaus (Cafeteria). In den Endjochen tragen gekreuzte Zugstäbe zur Verminderung auftretender Windlasten bei. Fußbodenheizung sollte der Auskühlung an Wochenenden entgegenwirken.

Im Obergeschoss begrenzen halbhohe Schrankwände Sekretariate, die den Unterrichtsräumen zugeordnet waren.

A corner office on the ground floor of the training center looking toward the smaller section of the pavilion (cafeteria). The final bays have crossed tie beams to minimize possible wind loads. Floor heating was used to counteract the cooling down of the building on weekends.

On the upper floor, half-height office closets assigned to the classrooms.

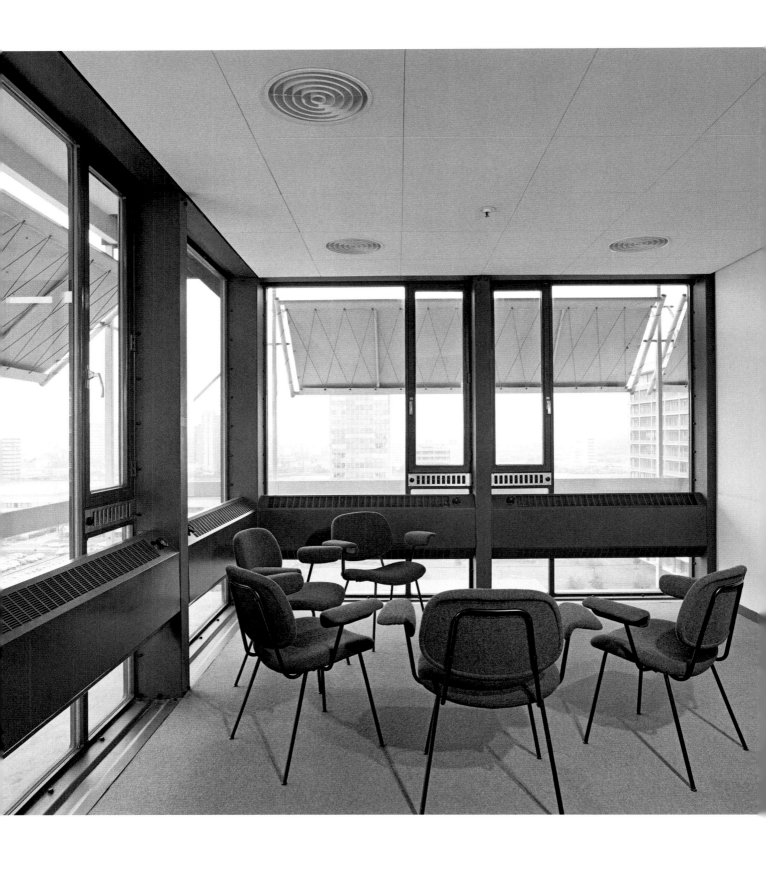

Arbeitsräume im Verwaltungsturm

„Natürlich wird jeder Architekt … wegen seines moralischen Alibis sich an die Brust schlagen und den Menschen vor die Funktion stellen. Ich denke nicht daran. Mir genügt es, wenn in den Büros das Gefühl vermittelt wird, dass an seinem Arbeitsplatz keiner bevorzugt, aber auch keiner benachteiligt wird, und wenn es dem Architekten gelingt, durch die gebaute Umwelt gesunde psychologische und physiologische Bedingungen für den arbeitenden Menschen zu schaffen, das heißt, dass er die Arbeit, die er zu seiner und seiner Familie Ernährung, aber nicht freiwillig leistet, möglichst fröhlich tut."[14]

14 Egon Eiermann, Interview in: Bauwelt,1972, Heft/*issue* 13, S./*p.* 518.

Working space in the office tower

"Of course every architect … will beat his breast because of his moral alibi and place the person before the function. I do not believe this. For me it is enough when in the offices the feeling is created that no one is privileged in his working space, but also that no one is disadvantaged. When the architect succeeds in creating healthy psychological and physiological conditions for the working person through the constructed environment, then that means that the architect performs his job, which he does—but involuntarily— to feed his family, as happily as possible."[14]

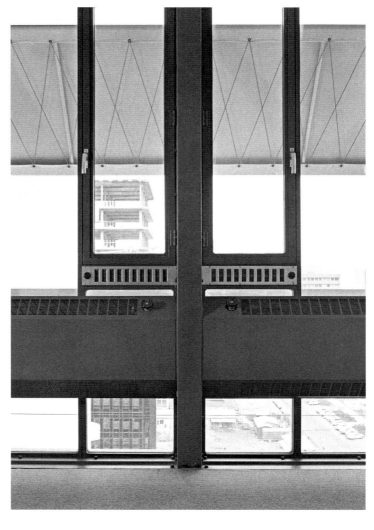

Ich möchte als ein Liebender des Stahls sagen, dass für mich der Stahlbau das aristokratische Prinzip des Bauens darstellt ... Stahlbauten verlangen beste Kenntnisse, verlangen logische Klarheit bis in den letzten Detailpunkt hinein und klassische Besonnenheit, die sich nicht zuletzt in der Anwendung des rechten Winkels als optima ratio äußert ... Was mich aber am meisten beschäftigt und was mich zum Stahl mit all meinen Neigungen hinzieht, ist die Tatsache: Der Stahl ist wegnehmbar ... Dem Stahl fehlt der freche Anspruch auf Dauerhaftigkeit auch dessen, was nicht von Dauer sein sollte; und das macht mich zum Liebhaber des Stahls.

As a devotee of steel I would like to say that steel construction for me represents the aristocratic principle of building. ... Steel buildings require the most knowledge, require logical clarity up to the last detail, and classical circumspection, not least expressed in the application of the right angle as optima ratio. ... What intrigues me most, and draws me to steel most intensely, is the fact that steel can be removed. ... Steel is lacking the brazen claim to the permanence of what should not be permanent; and that makes me a devotee of steel.

Egon Eiermann

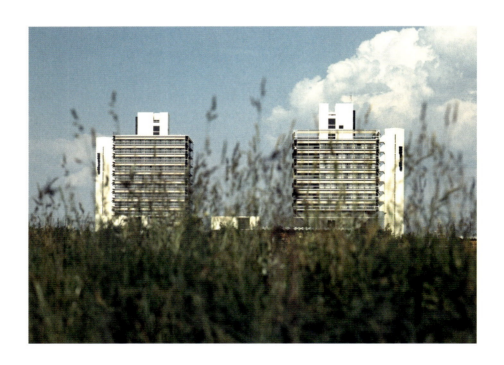

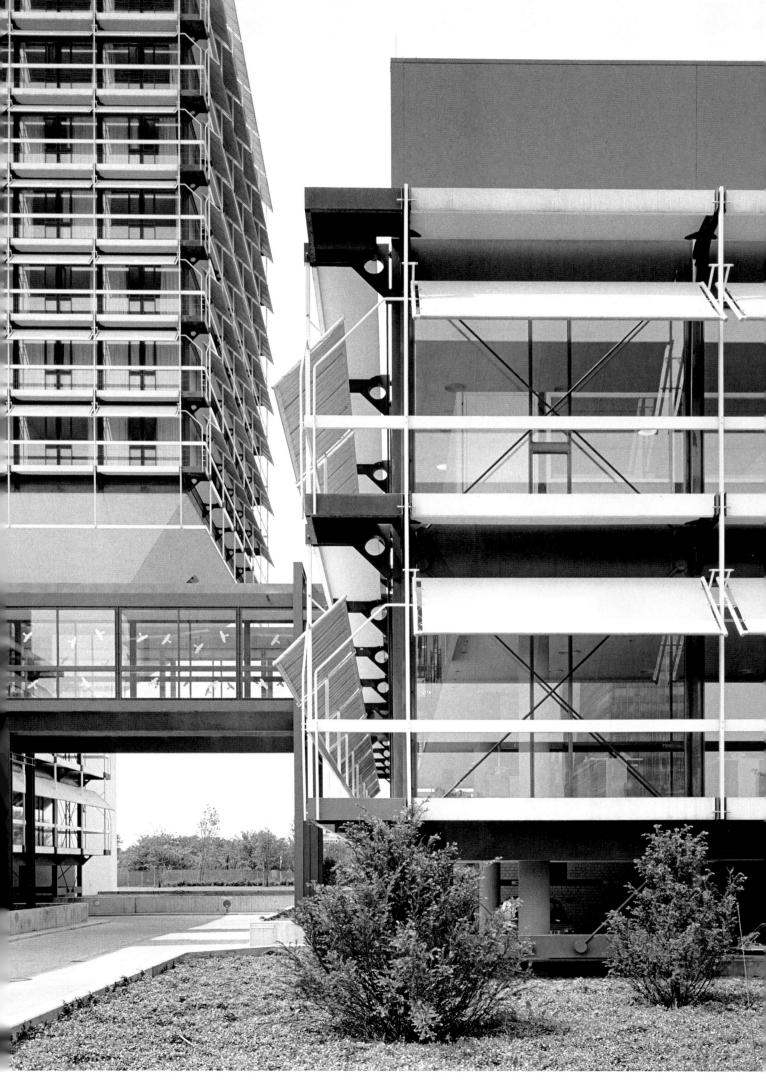

| Die Tugenden des Architekten sind Sauberkeit, Klarheit und Wahrheit bis ins kleinste Detail. Es sind die Tugenden des Ingenieurs ... Das bewusste Reduzieren, das Weglassen, das Vereinfachen hat eine tiefe ethische Grundlage: Nie kann etwas zuwider sein, was einfach ist. | The virtues of the architect are cleanliness, clarity, and truth up to the most minute detail. These are the virtues of the engineer. ... Deliberate reduction, omitting, simplifying, have a profound ethical foundation: Anything that is simple can never be displeasing. |

Egon Eiermann

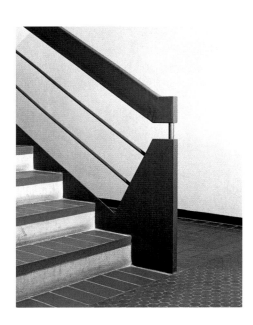

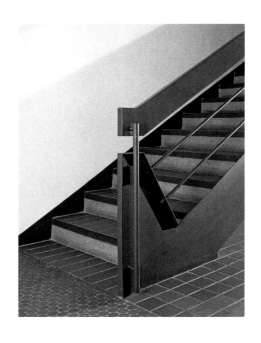

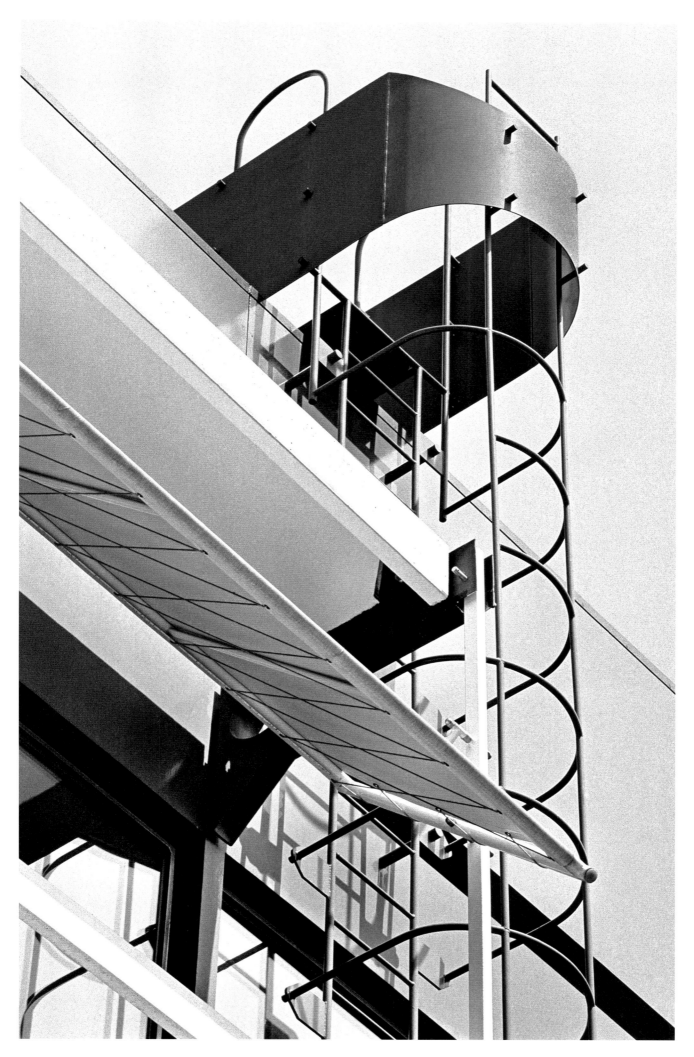

Die durchlöcherten Stahlblech-Konsolen, die an den Fassaden die Betontafeln der Umgänge tragen, sind an den negativen Gebäudeecken – wo sich zwei Konsolen treffen – zu einem komplexen Gebilde zusammengezogen. An diesem Punkt bildet das Stahlblechelement statt des Betonfertigteils bereits den Boden des Umgangs.

In ihrer rhythmischen Wiederholung bedeuten die dunklen Konsolen, was das klassische Ornament für das historische und historisierende Bauen bedeutet hatte. Die Inszenierung des filigranen Formen-‚Vorhangs' reicht hier über jeden Nutzzweck hinaus. Eiermann war einen weiten Weg über seine frühere Selbstverpflichtung hinaus gegangen, „so unauffällig wie nur irgend möglich zu bauen".[15]

At the "negative" corners of the building, where two brackets meet, the perforated steel plate brackets on the facade that support the walkway's concrete plates have been fused into a complex shape. The steel plate elements function as the floor at these corners of the walkway instead of the prefabricated concrete plates.

In their rhythmic repetition the dark brackets fulfill the significance of classical ornament for historical and historicizing architecture. The mise-en-scène of the filigree formal curtain here goes beyond any utilitarian purpose. Eiermann had gone far beyond his early commitment to "build as unobtrusively as possible."[15]

15 Egon Eiermann: Vorlesungstext nach undatierter Tonbandaufzeichnung, Archiv saai, zitiert/quoted in Carsten Krohn:
Vermeiden der architektonischen Geste, in Jaeggi (Hg./ed.): a.a.O./op. cit., S./p. 70.

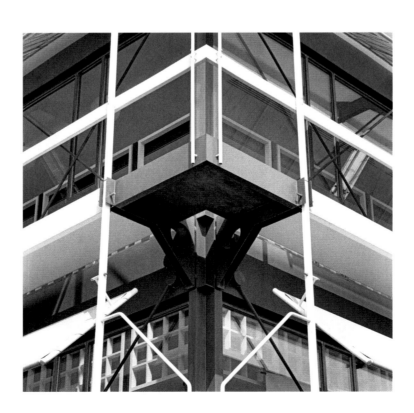

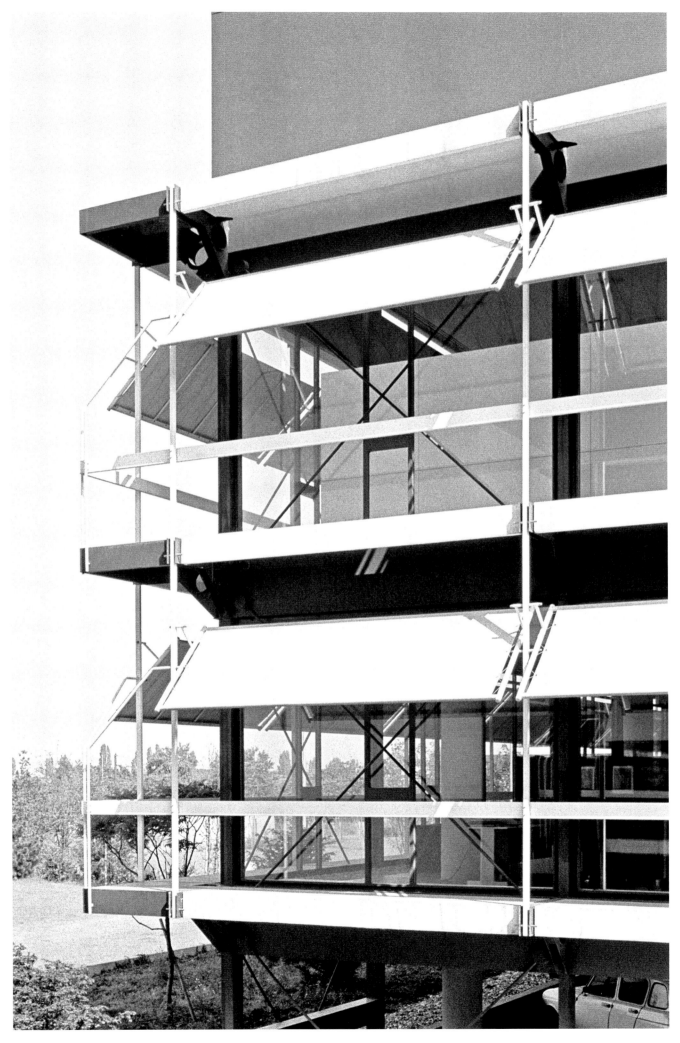

| Untersichten des Vordachs | View from below of the canopy |

Eingangssituationen haben immer die Architekten gereizt. Eiermann reagierte mit einer hochkomplizierten Konstruktion. Ein quer liegendes Stahlrohr unter dem Hohlkasten des Vordachs nimmt Zugseile und Abspannstangen auf.

Entrances have always stimulated architects. Eiermann reacted here with a highly complex construction. A transverse steel pipe under the hollow container of the canopy anchors the cables and lateral braces.

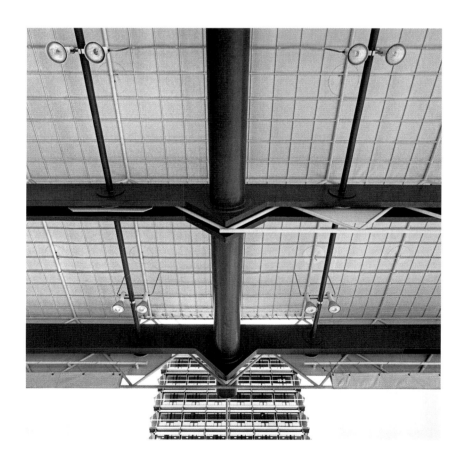

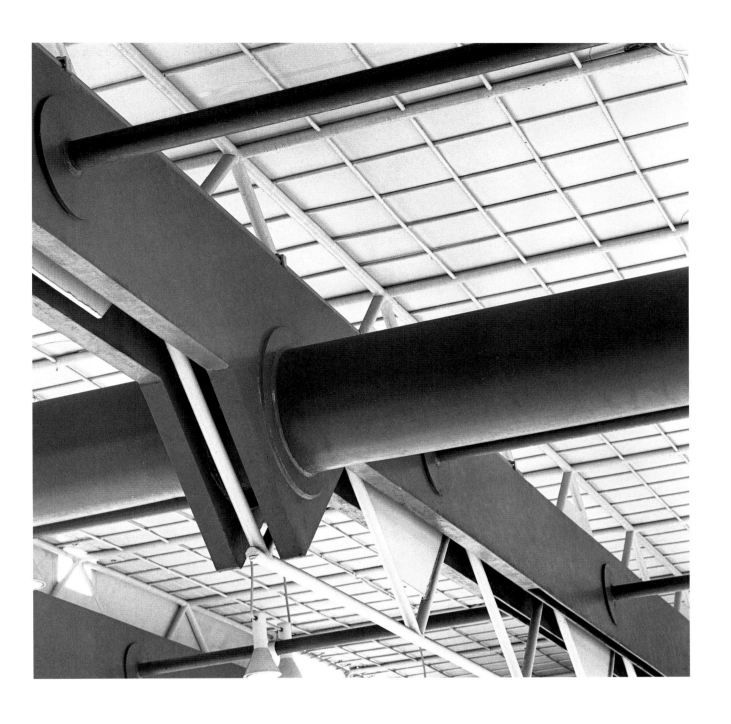

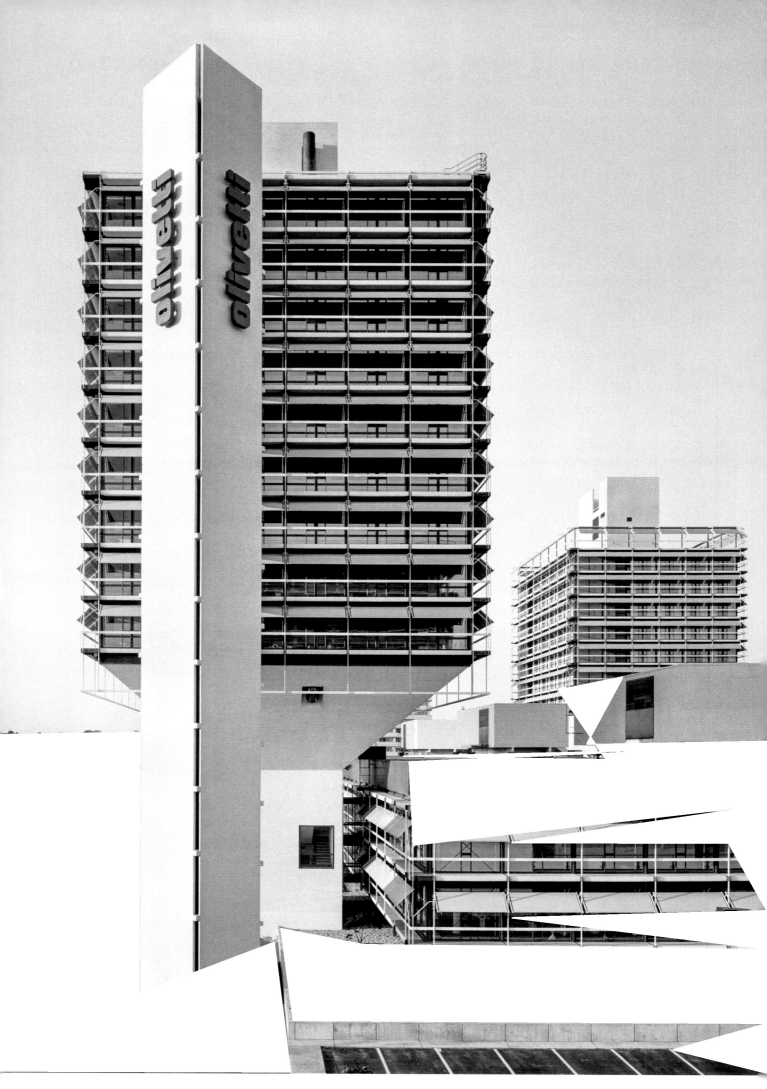

Nach dem Tode von Adriano Olivettis Sohn Roberto 1985 ging das Unternehmen Symbiosen mit anderen Firmen ein. Als Hersteller eleganter bürotechnischer Hardware zog es sich vom Markt zurück. Die Frankfurter Olivetti-Filiale in Niederrad wechselte bereits zweimal ihren Eigentümer. Für die architektonische Revitalisierung in den Jahren 1995 bis 2000 – zunächst noch unter der Zuständigkeit von Olivetti – war das Offenbacher Büro Andreas Pielok und Hans-Martin Marquardt Architekten verantwortlich. Die äußere Gestalt blieb im Wesentlichen unangetastet, während das Innere neuen Mietern angepasst wurde.

Wenn der Frankfurter Olivetti-Komplex einen Schlusspunkt im Werk Eiermanns darstellte, so bedeutete er den Beginn in der Karriere des Architekturfotografen Klaus Kinold. Zunächst hatte Kinold in München, dann an der Karlsruher Technischen Universität Architektur studiert, wo Egon Eiermann ein begeisterungsfähiger und begeisternder Lehrer war. Kinold entschied sich bei seiner Diplomarbeit für den Lehrstuhl Rudolf Büchner, wo er als studentische Hilfskraft mit festem Salär übernahm, was dort an fotografischen Arbeiten anfiel. Das sprach sich auch am Nachbar-Lehrstuhl Eiermanns herum. Eiermanns Assistent Heinz Jakubeit vermittelte. Kinold durfte erst die Modelle von IBM und Olivetti aufnehmen, dann die Rohbauten und nach Eiermanns Tod die fertigen Bauwerke selbst. Kinolds Fotografien, während der Entstehungszeit aufgenommen, haben infolgedessen außer ihren ästhetischen Qualitäten auch dokumentarischen Wert.

Kinold ist überzeugt, bei Eiermann Entscheidendes auch für die Kunst des Fotografierens gelernt zu haben, über die Wahl des Ausschnitts, die Gesetzmäßigkeit des Gegenstands, die angemessene Lichtstimmung, die subtile, sachgerechte Wiedergabe. Eiermann nahm sich Zeit sogar für Korrekturen, die er dem Novizen auf die Hochglanzabzüge zeichnete. Der junge Fotograf revanchierte sich. Was wir über Eiermanns späte Bauten, ihre Entstehung und Materialität wissen, verdanken wir nicht zuletzt den differenzierten und differenzierenden Aufnahmen Klaus Kinolds. „Ich will Architektur zeigen, wie sie ist", lautete der Titel einer der frühen Ausstellungen, die seinem fotografischen Werk gewidmet waren.[16]

After the death of Roberto, Adriano Olivetti's son, in 1985 the company merged with other corporations. It retired from the market as a manufacturer of elegant office hardware. The Frankfurt Olivetti branch in Niederrad changed owners twice. Its architectonic rejuvenation was carried out in the years from 1995 to 2000 —initially under the responsibility of Olivetti— by the studio of Andreas Pielok and Hans-Martin Marquardt in Offenbach. The external building was left unchanged in its essence, while the interior was adapted for new tenants.

If the Frankfurt Olivetti complex represents a key point in Eiermann's oeuvre, it also represents the beginning of the career of the architecture photographer Klaus Kinold. Kinold studied architecture first in Munich and then at the Technical University of Karlsruhe, where Egon Eiermann was an enthusiastic and stimulating teacher. For his diploma thesis Kinold chose the professor Rudolf Büchner as supervisor, for whom he was hired as a student assistant with a fixed salary, responsible for taking care of all photographic tasks. His work became known to Büchner's colleague Eiermann. Eiermann's assistant professor Heinz Jakubeit established the contact. Kinold was allowed first to photograph the models of the IBM and Olivetti buildings, then the unfinished constructions in their shell form, and after Eiermann's death the completed buildings. Kinold's photographs, taken during the construction process, thus possess documentary value in addition to their aesthetic quality.

Kinold is convinced that he learned decisive principles of the art of photography from Eiermann, such as the choice of detail, the innate nature of the object, the appropriate luminous atmosphere, the subtle, proper representation. Eiermann even took time for corrections, drawing them on glossy prints for the novice. The young photographer returned the favor. What we know about Eiermann's later projects, their process of creation and their materiality, comes not least from the differentiated and differentiating images by Klaus Kinold. "I want to show architecture how it is," is the title of an early exhibition of his, dedicated to his photographic work.[16]

16 Ulrich Weisner (Hg./*ed.*): Klaus Kinold, Fotograf. Ausst.-Katalog/*exh. cat.* Kunsthalle Bielefeld, 1993.

Nachtaufnahme Olivetti

Als ich an einem Freitagnachmittag des Jahres 1972 in der Olivetti-Niederlassung in Frankfurt-Niederrad eintraf, meldete ich mich wie vereinbart beim zuständigen Direktor. Ich fragte ihn nach der Möglichkeit, auch am Wochenende im Inneren der Gebäude fotografieren zu können. Der Albergo sei als Hotelunterkunft für die Auszubildenden durchgehend in Betrieb, für den Verwaltungstrakt gab er mir seinen Generalschlüssel mit den Worten: „Damit können Sie überall rein, aber nur nicht verlieren, das Auswechseln aller Schlösser kostet eine Viertelmillion." Ich weiß nicht mehr, was überwog: meine Angst oder meine Freude über ein ungestörtes Arbeiten. Um die großzügige Transparenz der Stahlkonstruktion zu verdeutlichen, bereitete ich dann am Sonntagabend als letztes Foto eine Nachtaufnahme, genauer gesagt: ein Foto in der Dämmerung, vor. Ich bat den Hausmeister, der angewiesen worden war, mir bei meinen Arbeiten behilflich zu sein, rechtzeitig in allen Räumen auf der Ostseite des Verwaltungstraktes, das Licht einzuschalten. Der Hausmeister verschwand im Gebäude und während ich draußen die Großbildkamera auf der gegenüberliegenden Straßenseite aufbaute, erhellte sich Etage für Etage die Fassade. Nur in der Mitte des Verwaltungsturmes blieben vier Fensterachsen dunkel. Ich wusste, mir blieb nur noch wenig Zeit, um die Aufnahme in der Dämmerung zu machen, dann, wenn das Kunstlicht vom Inneren langsam nach draußen dringt, außen aber noch genügend Tageslicht vorhanden ist, um die Konstruktion des Gebäudes auf dem Negativ durchzuzeichnen. Handys gab es ja noch nicht, und so lief ich aufgeregt dem Hausmeister, der im Haupteingang erschien, entgegen und zeigte ihm die schwarzen Felder in der sonst strahlenden Fassade. Bedauernd zuckte er die Schultern und erklärte: Zu diesen Räumen habe er keinen Zutritt, denn dort würden in den Computern die geheimen Daten der industriellen Großkunden bearbeitet. Ich übergab ihm meinen Generalschlüssel mit den Worten: „Ihr Chef hat mir versichert, damit könne ich in alle Räume", und bat ihn eindringlich mit Hinweis auf die hereinbrechende Dunkelheit, den Schlüssel auszuprobieren. Kopfschüttelnd verschwand er im Inneren des Gebäudes. Ich lief zur Kamera zurück, legte die Filmkassette ein und wartete voller Spannung. Plötzlich gingen auch in den dunklen Fenstern die Lichter an, und ich machte erleichtert nebenstehende Aufnahme. Als mir der Hausmeister den Schlüssel zurückgab, bemerkte er kleinlaut: Er hätte nicht gedacht, dass ich als Fotograf Zugang zu Räumen habe, die ihm als Hausmeister verschlossen blieben. Als ich am nächsten Tag nach Karlsruhe zurückfuhr, regnete es in Strömen, eine Nachtaufnahme wäre nicht mehr möglich gewesen. Und so lernte ich gleich bei meinem ersten größeren Auftrag, wie man als Architekturfotograf doch von den äußeren Umständen und vom Glück abhängig ist.

Klaus Kinold

Night photograph Olivetti

When I arrived at the Olivetti offices in Frankfurt-Niederrad on a Friday afternoon in 1972, I reported to the responsible director as arranged. I asked him about the possibility of photographing during the weekend inside the buildings. The Albergo was constantly in use as a hotel accommodation for trainees, he explained, but for the administration tower he gave me his master key with the words: "With this you can go everywhere, but don't lose it, because changing the locks will cost a quarter million." I am not sure what was stronger, my fear or my joy at working unhindered. In order to capture the ample transparency of the steel construction, I made preparations for a last, nighttime photograph on Sunday evening, more precisely, a photograph during the twilight. I asked the caretaker, who had been instructed to assist me in my work, to turn on all the lights on the east facade of the office tower in time for the twilight. The caretaker disappeared in the buildings and while I set up the large-format camera on the opposite side of the street the facade lit up story by story. Except for four windows in the middle of the tower. I knew that I only had little time left to take the photograph in the twilight, when the artificial light softly glowed from the interior, yet enough daylight was still left to trace the construction of the building on the negative. Mobile phones were not yet available those days, so I ran hurriedly to the caretaker, who appeared in the main entrance, and pointed to the black rectangles in the otherwise radiant facade. He shrugged his shoulders in regret and explained that he did not have access to these rooms, since the confidential data of major industrial clients was processed in the computers in those very rooms. I gave him the master key with the words, "your boss ensured me that I could go into all of the rooms," and beseeched him with insistence to try the key, explaining that it would soon be too dark. Shaking his head he disappeared again into the building. I ran back to the camera, placed the film magazine in the camera, and waited nervously. Suddenly the dark windows became illuminated and I took the photograph shown on the opposite page. When the caretaker returned the key to me he remarked a bit sheepishly that he had not thought a photographer would have access to rooms that were off-limits to him as caretaker. When I returned to Karlsruhe the next day it was pouring rain, a nighttime photograph would have not been possible anymore. And so in my first big job I learned how much an architecture photographer depends on external conditions and on luck.

Klaus Kinold

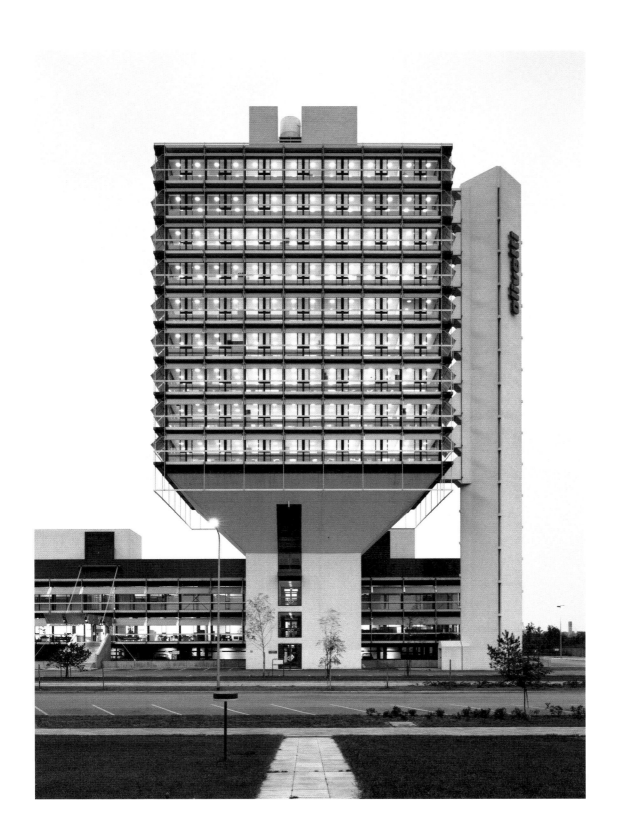

Erfolg zu haben bedeutet, von sich aus mehr zu tun, als erwartet wird.

Egon Eiermann

Having success means doing more than is expected of you.

Egon Eiermann

1904	Geboren am 29. September in Neuendorf, Kreis Teltow bei Potsdam	Born on September 29 in Neuendorf, Teltow county near Potsdam
1922	Abitur in Nowawes, danach praktische Tätigkeit in Bauhandwerken	Secondary school examination in Nowawes, than practical work in the building trade
1923–1927	Architekturstudium und Diplom an der Technischen Hochschule Berlin-Charlottenburg	Graduates with a diploma in architecture from the Technische Hochschule Berlin-Charlottenburg
1925–1928	Meisterschüler bei Hans Poelzig	Member of Hans Poelzig's master class
1928–1930	Architekt bei Karstadt AG Hamburg und Berliner Städtische Elektrizitätswerke AG	Architect for Karstadt AG Hamburg and Berliner Städtische Elektrizitätswerke AG
1930–1945	Selbständiger Architekt in Berlin, bis 1934 in Bürogemeinschaft mit Fritz Jaenecke	Freelance architect in Berlin, joint studio with Fritz Jaenecke until 1934
1931	Mitglied des Deutschen Werkbundes	Member of the Deutscher Werkbund
1933	Mitglied des Bundes Deutscher Architekten	Member of Bund Deutscher Architekten
1936	Erste von drei Reisen in die USA	First of three trips to the USA
1937	Reise zur Weltausstellung Paris	Visit to World's Fair in Paris
1945–1948	Selbständiger Architekt in Buchen und in Mosbach (Odenwald), ab 1948 in Karlsruhe	Freelance architect in Buchen and in Mosbach (Odenwald), from 1948 on in Karlsruhe
1946–1966	Bürogemeinschaft mit Robert Hilgers	Joint studio with Robert Hilgers
1947–1970	Professor für Architektur an der Technischen Hochschule Karlsruhe	Professor for architecture at Technische Hochschule Karlsruhe
1951	Gründungsmitglied des Rates für Formgebung	Founding member of the Rat für Formgebung
1962	Mitglied des Planungsrates für die Neubauten des Bundestages und Bundesrates, Bonn	Member of Planning Commission for New Buildings of the German Parliament and Senate, Bonn
1963	Honorary Corresponding Member, Royal Institute of British Architects, London	Honorary Corresponding Member, Royal Institute of British Architects, London
1968	Großer Preis des Bundes Deutscher Architekten Großes Bundesverdienstkreuz	Grand Prize from the Bund Deutscher Architekten Grand Federal Service Cross
1970	Mitglied des Ordens Pour le Mérite für Wissenschaft und Künste der Bundesrepublik Deutschland	Member of the Order Pour le Mérite for Sciences and Arts of the Federal Republic of Germany
	Gestorben am 19. Juli in Baden-Baden	Dies on July 19 in Baden-Baden

Impressum / Imprint

Herausgeber/Editor:
Klaus Kinold

Text/Texts:
Wolfgang Pehnt

Gestaltung/Design:
Klaus Kinold, Dagmar Zacher

Übersetzung/Translations:
David Sánchez

Lithographie/Separations:
Serum Network, München

Druck und Bindung/Printing and binding:
Graspo, Zlín

Printed in Czech Republic

© Hirmer Verlag GmbH, München/Munich
© Fotografien: Klaus Kinold, München/Munich
© Text: Wolfgang Pehnt, Köln/Cologne

Architekturmodell für die Präsentation bei Olivetti/
Architectural model for the presentation at Olivetti,
S. 4–5/pp. 4–5
Porträtfoto/Portrait Egon Eiermann, S./p. 70
Wolfgang Roth

Autor und Herausgeber bedanken sich für die Genehmigung zum Abdruck der Zeichnungen und Pläne bei/Author and editor thank the saai | Südwestdeutsches Archiv für Architektur und Ingenieurbau am Karlsruher Institut für Technologie (KIT) for permission to print drawings and plans.

Die deutsche Nationalbibliothek verzeichnet diese Publikation in der Deutschen Nationalbibliografie; detaillierte bibliografische Angaben sind im Internet über http://dnb.de abrufbar/ The Deutsche Nationalbibliothek holds a record of this publication in the Deutsche Nationalbibliografie; detailed bibliographical data can be found at http://dnb.de

ISBN 978-3-7774-3312-7

www.hirmerverlag.de

Mit dieser Buchhandelsausgabe erscheinen nummerierte und signierte Vorzugsausgaben mit einem Originalfoto von Klaus Kinold (Silbergelatineprint, 21 × 30 cm).

Along with this trade edition, numbered and signed special editions with an original photo by Klaus Kinold (silver gelatin print, 21 × 30 cm) are also being issued.

Erhältlich bei/available at:
www.storms-galerie.de